THE PITTSBURGH PIRATES' 1960 SEASON

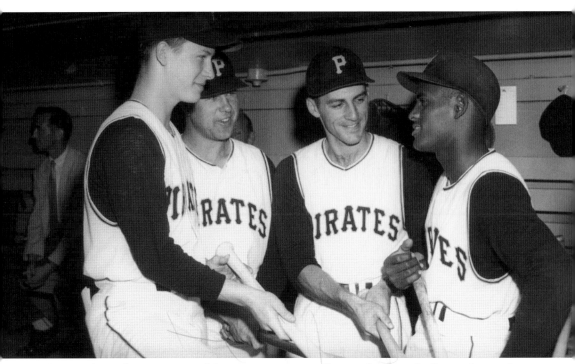

Among these players are two of the most important offensive forces in the Pirates lineup during the 1960 campaign, shortstop Dick Groat (second from right) and right fielder Roberto Clemente (far right). For Groat, it was a marquee season, as he led the league in hitting with a .325 mark. Clemente hit .314 with a team high 94 RBIs. Despite the fact that Groat missed almost the entire last month of the season, he still captured the MVP award. Clemente finished a distant eighth. (Courtesy of the Pittsburgh Pirates.)

FRONT COVER: Pictured in the insert is third baseman Don Hoak, popping open a bottle of champagne to celebrate the Pittsburgh Pirates' third World Series championship. A former Marine, Hoak began his professional sports career as a boxer before switching to baseball after seven consecutive losses. His second career choice proved the correct one, as he hit .265 in 11 major-league seasons. (Courtesy of the Pittsburgh Pirates.)

COVER BACKGROUND: After winning the 1960 World Series on Bill Mazeroski's ninth-inning, game-seven home run, jubilant Pirates fans pour onto the field, setting off one of the wildest celebrations in the city's history. It was a moment of unrestrained joy. A decade of frustration was erased with this world championship. (Courtesy of the Pittsburgh Pirates.)

BACK COVER: It was a once-in-a-lifetime moment for second baseman Bill Mazeroski and the rabid fans of the Pittsburgh Pirates when he became the only player in baseball history to end a World Series game seven with a walk-off home run. Seen here rounding third base surrounded by excited fans, Mazeroski went on to become one of the greatest defensive second basemen in the history of the game. He was elected to the National Baseball Hall of Fame in 2001. (Courtesy of the Pittsburgh Pirates.)

THE
PITTSBURGH
PIRATES'
1960 SEASON

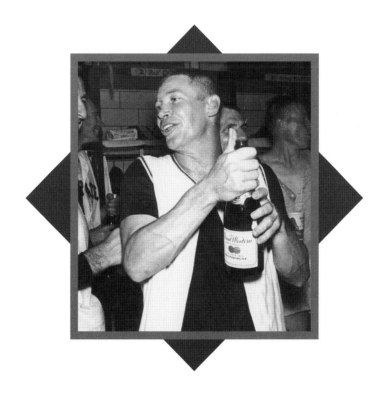

David Finoli

ARCADIA
PUBLISHING

Published by Arcadia Publishing
Charleston, South Carolina

Printed in the United States of America

Library of Congress Control Number: 2014954880

For all general information, please contact Arcadia Publishing:
Telephone 843-853-2070
Fax 843-853-0044
E-mail sales@arcadiapublishing.com
For customer service and orders:
Toll-Free 1-888-313-2665

Visit us on the Internet at www.arcadiapublishing.com

To my mother-in-law, Vivian Pansino, who spent the greatest summer of her life in 1960 rooting on her favorite team, the Pittsburgh Pirates.

CONTENTS

ACKNOWLEDGMENTS

Perhaps the most frustrating thing in a lifetime of following sports is the fact that I never had the chance to experience the once-in-a-lifetime occurrence that was the 1960 Pittsburgh Pirates. While I was not there myself, I have been honored to hear the stories and details from some of the knowledgeable members of my family, such as my father, Domenic, and my mother-in-law, Vivian Pansino, who have told me several thrilling stories through the years. These have always piqued my interest in this incredible story.

For this book, as with any venture, the support of family is essential, and, as always, mine provides more than I could ever have hoped for. I would like to thank the following: my wife of 30 years, Vivian; my wonderful children, Cara, Matthew, and Tony; my dad; brother Jamie; sister Mary; nieces Marissa and Brianna; my aunts Betty, Maryanne, and Louise; the memories of my mother, Eleanor; my aunts Norma, Libby, Jeannie, and Evie; my uncles Vince and Ed; cousins Fran, Luci, Flo, Ginny Lynn, Eddie, Pam, Debbie, Tom A., Amanda, Claudia, Rich, Diane, Vinnie, Tom D., Gary, Amy, and Linda; and, last but not least, Beth; as well as all of their children.

This is my 17th book and, as always, I have one of the greatest roundtables of Pirates fans to bounce ideas off of. Bill Ranier, Chris Fletcher, Ray Stefanacci, Pat Didiano, Dan Russell, Matt O'Brotka, Rich Boyer, and Bob O'Brien are some of the greatest Pirates historians and fans of our generation. Jim Tridinch and the Pirates organization also deserve a huge thank-you for the generous use of photographs for this book as well as the support of my projects that they have always given me.

Finally, of all the projects I have been involved with, there are few better partners than Arcadia Publishing. A thank-you goes to the entire staff, especially Abby Walker, who was invaluable, as always, in making this idea become a reality.

Unless otherwise noted, all photographs are courtesy of the Pittsburgh Pirates.

INTRODUCTION

A sports fan is lucky if, once in their life, they experience a season when the club they root for defies all expectations, fighting through the odds to not only succeed, but win a world championship. As the 1960s began, sports fans in the Steel City had just come out of a decade that, except for a few winning moments, was filled with one debacle after another. Enter the 1960 Pittsburgh Pirates, which wiped away all those years of disappointment.

In 1945, a group headed by John Galbreath purchased the Pirates from the longtime owners, the Dreyfuss family. Galbreath tried, two years later, to make the Bucs instant contenders by throwing money at the Tigers and their slugger, Hank Greenberg, acquiring him and making him the first $100,000 player in major-league history. It was a move not much different than that used by the modern-day Yankees and Dodgers, except that it failed to give Pittsburgh the success Galbreath envisioned. Instead of competing for pennants, the Pirates entered one of the worst eras in the history of the franchise.

Rather than continuing its pursuit of high-price talent, the Pittsburgh ownership group tapped another legend, Branch Rickey, to build the franchise from the ground up. Rickey had built championship franchises in St. Louis and Brooklyn, but the 68-year-old general manager did not get along with Dodgers owner Walter O'Malley and was forced out. Galbreath quickly signed the future hall-of-fame GM in hopes he could be as successful in Pittsburgh as he had been in his previous two positions.

Rickey did not have the immediate success he had hoped for, and he had not been able to lead the Bucs out of the second division when he left the team in 1955. In fact, his most notable achievement during his Pittsburgh tenure was getting rid of the team's lone superstar, Ralph Kiner, in 1953. What Rickey did, though, was give the club an infusion of young talent that included pivotal members of the 1960 team. New arrivals included Dick Groat, Roy Face, Dick Stuart, Bill Mazeroski, and the biggest icon the Steel City has ever known, Roberto Clemente.

Groat had been a superstar basketball player as well as a baseball player at Duke University. He was named UPI's Player of the Year in basketball and was an All-American in both sports. Groat had the honor of being the first Blue Devil to have his number retired, and he looked like he would have success in the NBA, averaging 11.9 points per game as a rookie first-round draft pick of the Fort Wayne Pistons. Rickey won a bidding war for Groat, a Wilkinsburg native, and convinced him to sign with his hometown baseball team.

Second baseman Bill Mazeroski, a 17-year-old prospect out of Wheeling, West Virginia, was inked in 1954 and quickly went through the Pirates system, making his debut in 1956. Face was picked up from Brooklyn via the Rule 5 draft in 1952, and Stuart was a 1951 selection in the amateur free agent draft. As successful as Groat, Face, Stuart, and Mazeroski turned out to be, Clemente was Rickey's most notable gift to the Pittsburgh sports landscape. The budding superstar from Carolina, Puerto Rico, was inked to a deal with the Dodgers, including a $10,000 bonus. The

amount was significant at the time. Since the bonus exceeded $4,000, Brooklyn had to either keep Clemente on the major-league roster or expose him to a draft. The Dodgers chose to send Clemente to their farm club in Montreal, hoping to hide him there. Bucs scout Clyde Sukeforth was not fooled and drafted him for Pittsburgh, where he made his major-league debut in 1955.

Along with Bob Friend and Vern Law, both of whom were signed shortly before Rickey took over, the five provided a nucleus that, by 1958, would lead the Bucs out of the doldrums to a surprising second-place finish that season. The team faltered a bit the following year, but came into the 1960 campaign wanting to show that 1958 was no fluke. After Rickey left in 1955, the team chose 37-year-old Joe L. Brown to lead the way. He soon brought on a former second baseman with the team, Danny Murtaugh, to manage the club. After he made some astute trades to acquire Bill Virdon, Vinegar Bend Mizell, Harvey Haddix, Don Hoak, and Smoky Burgess, the groundwork was set.

After a nine-game winning streak to end April, the team stood at 12-3 and in first place. They faltered in May, falling a game back on the 28th, but quickly rebounded, recapturing the top spot after an 8-5 victory over the Phillies the following day. The Pirates never fell behind the rest of the season. On September 25, despite losing to the Milwaukee Braves 4-2, the Bucs clinched their first National League pennant since 1927. It was a phenomenal season that saw Groat capture the league's MVP award and Law win the Cy Young Award, going 20-9.

Their reward for capturing the NL crown was a spot in the World Series against the powerful New York Yankees. When the Yankees won, they won big, outscoring Pittsburgh 38-3 in their three series victories. Somehow, though, the Pirates found a way to squeak out three close wins to send the series to a seventh and deciding game.

Things went well for Pittsburgh early on, with a 4-0 lead. But soon, the Pirates found themselves on the wrong end of a 7-4 game. They scored five runs in the bottom of the eighth, the final three coming off a Hal Smith home run to retake the lead 9-7. New York tied it in the top of the ninth, leading to the most dramatic ending in the history of the fall classic. Mazeroski etched his name in franchise lore with a leadoff home run to give Pittsburgh a 10-9 win, setting off a celebration the city had not seen before and has not seen since.

The 1960 championship by the Pirates is perhaps the most memorable in the city's history. Hopefully, fans will be able to relive those moments in the pages of this book.

FORBES FIELD

OPENED
June 30, 1909
Chicago 3, Pittsburgh 2
Attendance: 30,338

LAST GAME
June 28, 1970
Pittsburgh 3, Chicago 2 (W-Dave Giusti)
Pittsburgh 4, Chicago 1 (W-Jim Nelson)
Attendance: 40,918

CAPACITY
25,000 (original), 35,000 (final)

COST TO BUILD
$1 million

1960 RECORD AT FORBES FIELD
W L PCT RS RA
52 25 .675 362 287

1960 ATTENDANCE
1,705,828, a franchise record at the time
Finished third in the National League in attendance

1960 OPENING DAY
Thursday, April 14; Pittsburgh 13, Cincinnati 0 (W-Vern Law)
Attendance: 34,064

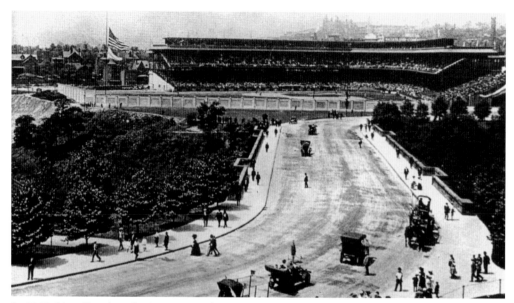

In 1909, $1 million bought Pirates president Barney Dreyfuss the National League's first steel-and-concrete stadium. After less than four months of construction, Forbes Field opened its doors on June 30, 1909, to a throng of 30,388 people. The team lost to the Chicago Cubs 3-2. The visitors took three out of four in that first series, but the Pirates eventually rebounded to capture the NL pennant.

Before Three Rivers Stadium, PNC Park, and Heinz Field were built on the north side of Pittsburgh, there was Exposition Park, the home of the Pirates. The historic park, which saw three National League pennants and the team's first World Series, was famous for its flooding issues, which necessitated the move to Forbes Field.

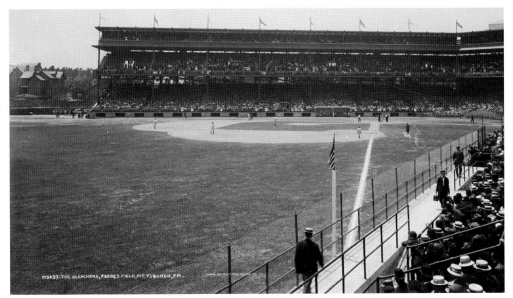

After its less-than-auspicious debut on June 30, Forbes Field became a good-luck charm for the 1909 Pirates. Despite the loss, Pittsburgh had an impressive 44-15 mark and a six-and-a-half-game lead for the pennant. After losing three of the first four games in their new facility, the Bucs went 65-26 the rest of the way to finish the 1909 campaign with an impressive 110-42 mark and their fourth NL championship. The Pirates played the Detroit Tigers in the World Series that year, taking the first game 4-1. It was the first fall classic game at Forbes Field. Pittsburgh went on to beat Detroit in seven games and capture its first World Series title.

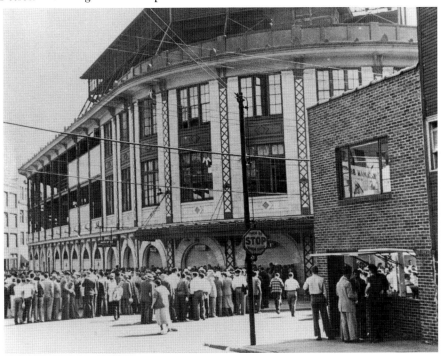

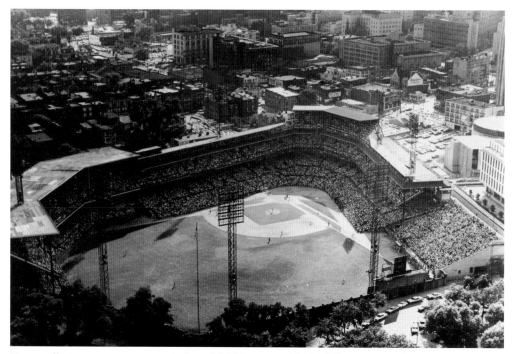

Eventually increasing its capacity from 25,000 to over 35,000 following renovations, Forbes Field stood as a magnificent structure in the middle of the University of Pittsburgh campus for 61 years. Parking may have been at a premium, but fans found their way to the Oakland section of the city to root on the Bucs.

On June 4, 1940, the Pittsburgh Pirates entered the modern era of baseball, playing their first night game. On that historic night, 20,310 people entered Forbes Field to see the Bucs crush Casey Stengel and the Boston Braves 14-2. Pittsburgh was led by Joe Bowman's five-hit complete game and Maurice Van Robays four RBIs.

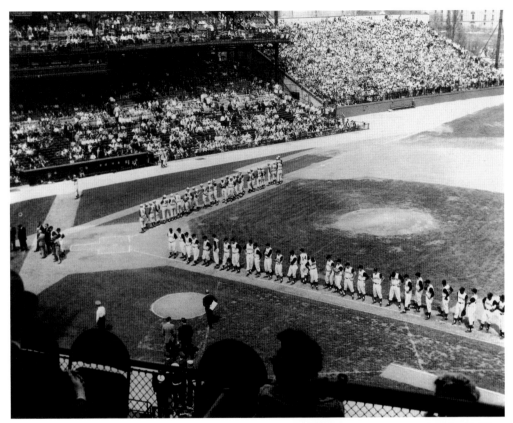

Opening day has become a ritual for Pirates fans, a celebration of the season about to unfold. In 1960, the fans and players were excited as 34,064 fans came on April 14 to witness an example of the magical season that was to come when Vern Law tossed a seven-hit shutout with the Bucs dominating the Cincinnati Reds 13-0. Future hall of famers Roberto Clemente and Bill Mazeroski led the way. Clemente knocked in five with a three-hit performance, and Maz chipped in with four RBIs and the team's first home run at Forbes that season—a shot over the left field fence in the second inning. It was almost the same spot where he would hit the team's last home run that year, on October 13.

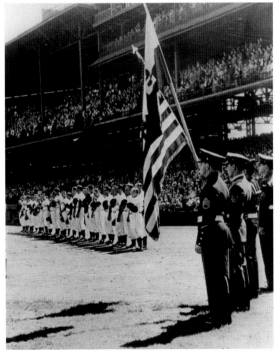

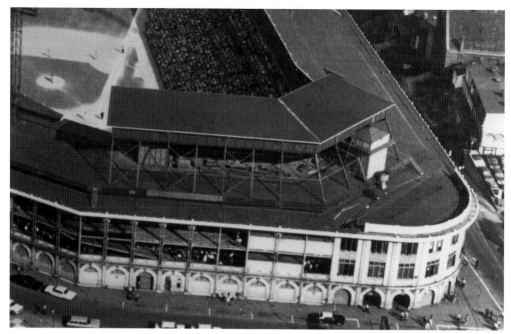

The Pirates began to play great baseball as they finished their first home stand of the season at Forbes Field. A crowd of 24,758 was on hand on April 24, with Pittsburgh shooting out to a 7-0 lead before holding on for a 7-3 victory. Starting pitcher Harvey Haddix struggled in the ninth inning, but the Bucs were 8-3 following the victory, vaulting them into first place for the first time.

In the 1960s, the San Francisco Giants were among the best teams in the National League. On May 22 at Forbes Field, the two struggled in a classic game that showed Pittsburgh's incredible comeback ability. In front of 30,123 fans, the home team was down 7-5 in the bottom of the ninth. Bob Skinner cracked a one-out, two-run homer to tie the game. In the 11th, the Pirates won on a Hal Smith single.

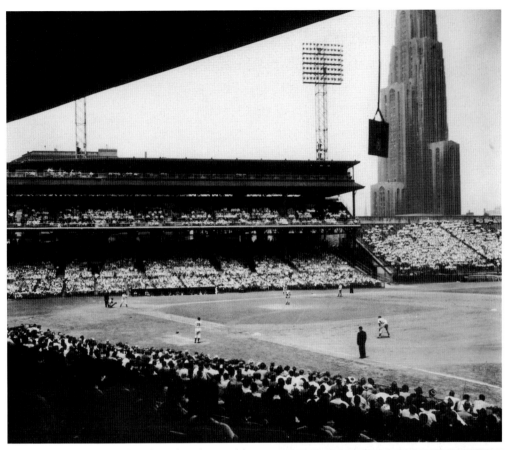

The University of Pittsburgh and Forbes Field were intertwined throughout the stadium's 61-year run (1909–1970). Visible in the above photograph is Pitt's Cathedral of Learning. Fans who sat along the first-base line had this view during games. Commissioned to be built in 1921 and dedicated in 1937, the Cathedral of Learning has been a Pittsburgh landmark for over nine decades. In 2007, the building was scrubbed of grime, a product of the smoke from the steel mills that operated for much of the 20th century. Spots are still visible at the building's base, indicating the extent to which the structure was stained by the industrial smoke.

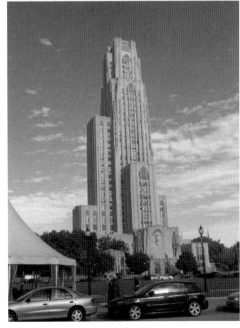

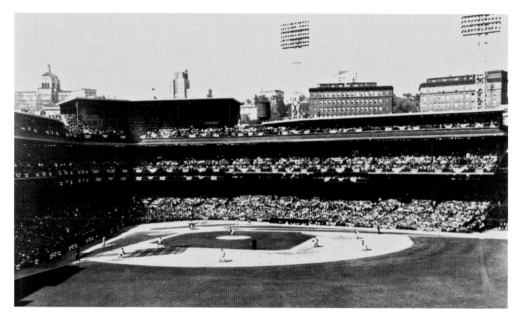

After blowing a 3-1 lead in the ninth inning on May 31 against the Cincinnati Reds, the Pirates showed 20,494 fans at Forbes Field just how resilient they were. In the 11th, Roberto Clemente stroked a single to center, scoring Bill Virdon to win the game 4-3. The Pirates' record stood at 27-14.

Following a long road trip that ended on the West Coast, the Pirates returned home. Only July 1, the team hosted the Dodgers. The crowd of 27,312 saw a thriller. After Los Angeles tied the score at 2-2 in the seventh, they went ahead 3-2 in the 10th. RBI singles by Roberto Clemente and Dick Stuart with two out in the bottom of the 10th gave the Bucs the 4-3 victory.

Shown here is a game on April 28, 1955, which the Pirates lost to the Cincinnati Reds. The loss dropped the team to 2-10 in a season that saw them win only 60 games. It would have been a shock to fans at that point to know that, in only five short seasons, this losing franchise would be transformed into world champions.

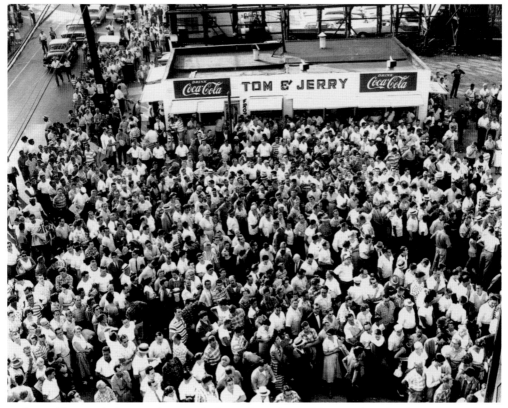

Forbes Field, named after British general John Forbes, a hero of the French and Indian War, was home to three World Series in its first 18 years. It would be 33 years before it hosted another. In 1960, a record 1,705,828 fans went through its turnstiles to cheer the Bucs to an unexpected championship season.

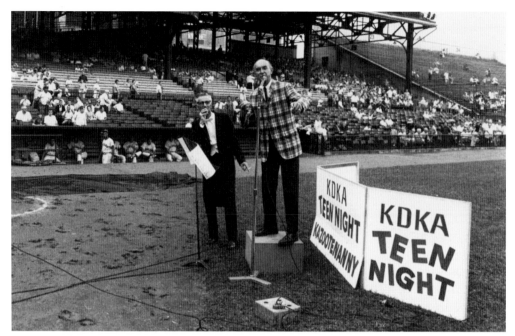

From the time it aired the first broadcast of a major-league game in the history of the sport in 1921, until 2006, when it lost its contract after 52 consecutive seasons, KDKA-AM had partnered with the Pirates. Pictured here is a contest the station ran at Forbes Field to promote teens coming to watch the Bucs. In 2011, KDKA reacquired the contract and now broadcasts games at 93.7 KDKA-FM.

Braving the rain on August 6, 1960, a crowd of 28,246 saw the Bucs blow a 5-3 lead in the ninth. The Giants tacked on two in the top of the 10th to go up 7-5. But, a single by Don Hoak and a sacrifice fly by Bill Virdon tied the game before Dick Groat remarkably won it with a two-out single.

This opening-day lineup at Forbes Field in the mid-1960s was part of a winning tradition that began in 1960. The team had a second-place finish in 1958 after being the laughingstock of the league, and followed that up with a 78-76 mark a year later. The Pirates put it all together in 1960, erasing the embarrassment of the previous decade.

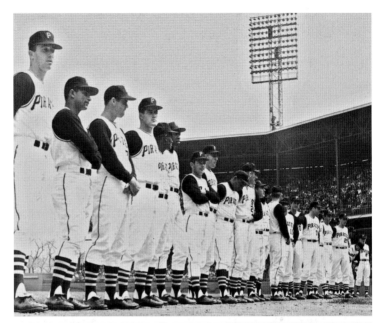

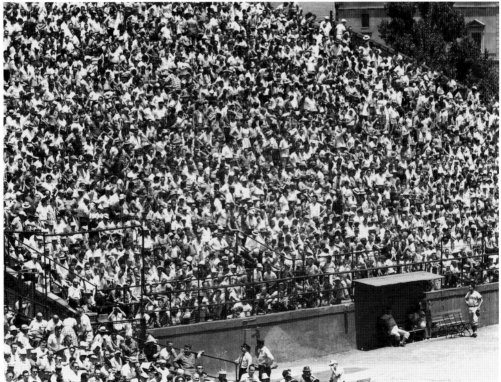

The left field bleachers were not the most comfortable seats at Forbes Field, and fans who sat there had an obstructed view of home plate. But the section was jammed on August 14, 1960, as 36,775 fans came to see the Pirates face the Cardinals in a doubleheader. After winning the first game 9-4, Pittsburgh won the nightcap 3-2 on a Don Hoak single in the bottom of the 11th.

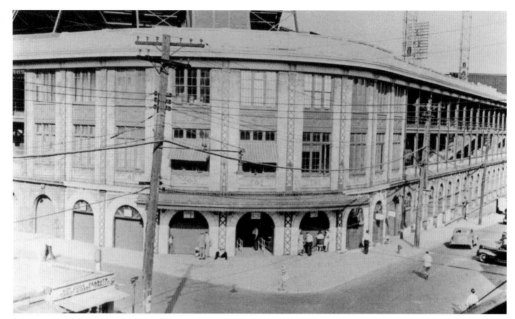

After clinching the NL crown in Milwaukee on September 25, the Pirates played before 22,162 excited fans two days later to face the Cincinnati Reds. After Pittsburgh broke out to a quick 3-0 lead in the first inning on a three-run homer by slugger Dick Stuart, the Reds chipped away and tied the score, sending the game into extra innings. The Pirates bullpen of Diomedes Olivo, Jim Umbricht, and Fred Green was dominant, allowing only four hits in seven innings as the game went into the bottom of the 16th. Finally, Dick Schofield ended the long contest with a single that scored Gino Cimoli, giving the home team a 4-3 win.

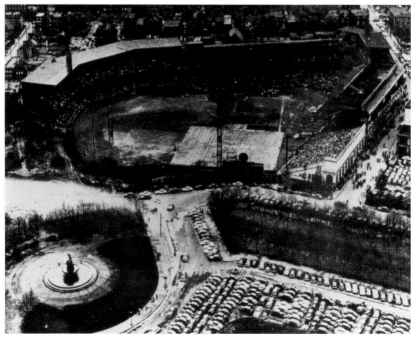

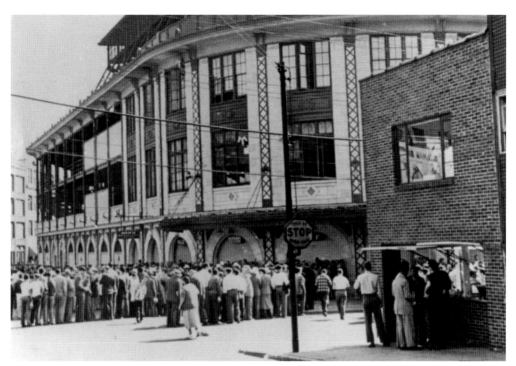

On October 2, 1960, the Pittsburgh Pirates played their last game of this phenomenal season against the Milwaukee Braves at Forbes Field. The stadium was full, as 34,578 fans came out to cheer on the National League champions. They defeated the Braves 9-5 for their 95th victory of the season, thanks to three-hit, two-RBI performances by Rocky Nelson and Dick Schofield.

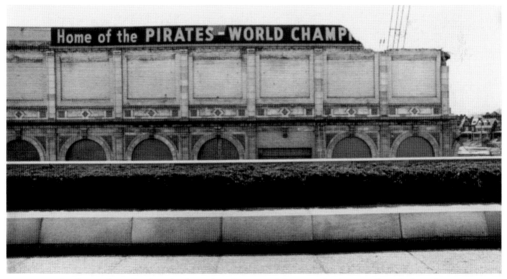

By 1970, the legendary facility had outlived its usefulness. The Bucs played their last games at Forbes Field in the first half of the season. Pictured here is a sign that stood outside the left field bleachers celebrating this exciting season. The sign certainly evoked wonderful memories from the Pirates fans who walked past it daily.

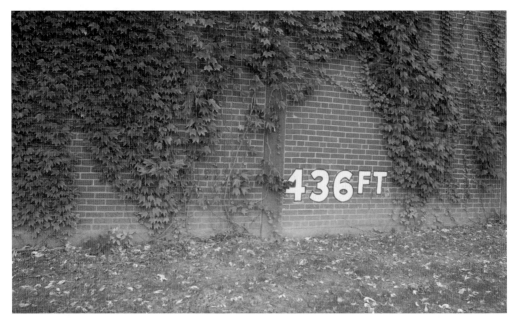

Forbes Field closed its doors in 1970. In its 61 years of existence, the facility saw three World Series, two world championships, performances by the great Homestead Grays, five undefeated seasons by the University of Pittsburgh football squad, and many wonderful contests by the Duquesne University and Carnegie Tech football teams. The stadium also hosted championship boxing, including the memorable heavyweight clash between Ezzard Charles and Jersey Joe Walcott, as well as the beginnings of a Pittsburgh treasure, the Steelers. Though destroyed, Forbes Field is not forgotten. Part of the famed brick outfield wall (above) still stands in Oakland, where it had for so many years. Another part of the wall (below) is incorporated into the Bill Mazeroski statue that sits by the river next to PNC Park. (Both, courtesy of David Finoli.)

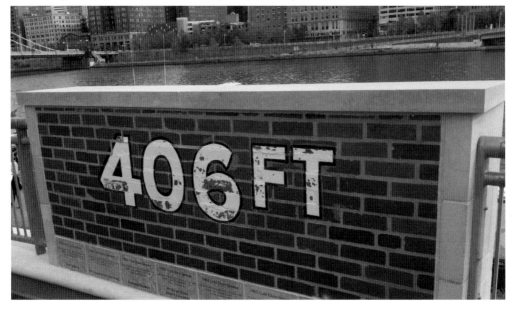

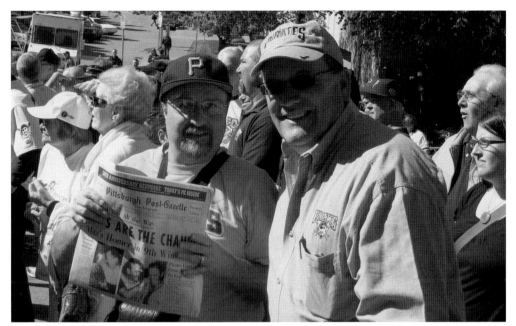

It was a Pittsburgh tradition that began innocently in 1985. Squirrel Hill resident Saul Finklestein decided to celebrate the 25th anniversary of game 7 of the 1960 World Series by listening to a cassette recording of the broadcast at the Forbes Field wall in Oakland while eating his lunch at the exact time the game began. The next year, he invited some friends to join him, and, as time went on, word of mouth made this an annual sojourn for Pirates fans. In 2010, the one-man tradition had become a big deal. Many players from the 1960 club came to celebrate the 50th anniversary, as did over 1,000 fans, including author and baseball historian Bill Ranier (above, left) and fan Dennis Gilfoyle (above, right). (Both, courtesy of David Finoli.)

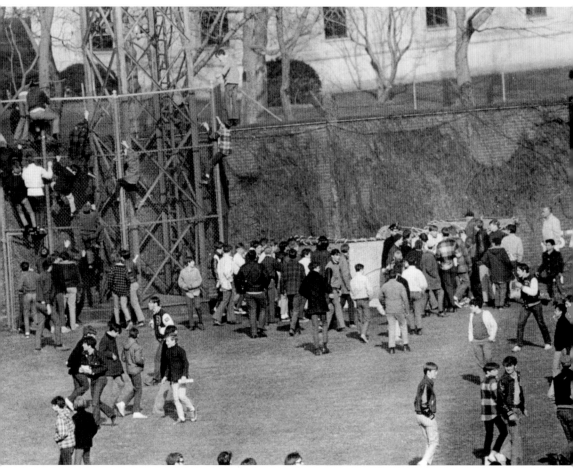

It was a day to celebrate, cry, and say good-bye to the only home the Pittsburgh Pirates had known since 1909, Forbes Field. On June 28, 1970, almost 61 years to the day the Bucs opened the stadium against the same Chicago Cubs franchise, 40,918 fans jammed every nook and cranny of the facility to bid it adieu. The Pirates won the first contest of the doubleheader, 3-2. In the second game, manager Danny Murtaugh chose rookie Jim Nelson to start. Al Oliver played for Roberto Clemente and had two hits, including the final home run at Forbes. With Pittsburgh up 4-1 in the bottom of the ninth and the Cubs' Willie Smith on first with two outs, reliever Dave Giusti served up a pitch to Don Kessinger, who hit the ball to 1960 World Series hero Bill Mazeroski. Maz scooped the grounder and made the final out, beating Smith to second. Moments later, thousands of rabid fans descended on the field (pictured) to take any souvenir of the park that they could find.

THE FRONT OFFICE

BOARD OF DIRECTORS
John Galbreath, president
Tom Johnson, vice president and secretary
Bing Crosby, vice president
Frank Denton, director
Dan Galbreath, director
Benjamin Fairless, director

GENERAL MANAGER
Joe L. Brown

MANAGER
Danny Murtaugh

COACHES
Bill Burwell, pitching coach
Lenny Levy, hitting coach
George Sisler, special assistant to the manager
Sam Narron, bullpen coach
Virgil Trucks, batting-practice pitcher
Frank Oceak, third-base coach
Mickey Vernon, first-base coach

Bill Benswanger was never supposed to run a major-league team. The insurance executive ascended to the head of the Pirates organization on the heels of two tragedies suffered by the family of his wife, Eleanor Dreyfuss. In 1931, the man who was to succeed Barney Dreyfuss as president, her brother Sammy, died of pneumonia. A year later, her grief-stricken father also passed away, prompting Dreyfuss's widow to ask Benswanger to run the team. His passions were the piano and music; he was president of the Pittsburgh Musician Club and the Pittsburgh Chamber Music Society. But he became an adept baseball executive. After 15 years, Benswanger facilitated the sale of the team to a group headed by real-estate developer John Galbreath. The 46-year ownership by the Dreyfuss family included six NL pennants and two World Series titles.

THE FRONT OFFICE

In 1946, the Dreyfuss family's 46 years of ownership came to an end, as John Galbreath (right), a real-estate developer from Derby, Ohio, headed a four-man group, including Tom Johnson, Frank McKinney, and Bing Crosby, that purchased the Pirates. The team began this new tenure of ownership, in the late 1940s and 1950s, as the worst franchise in the National League. The man on the left is unidentified.

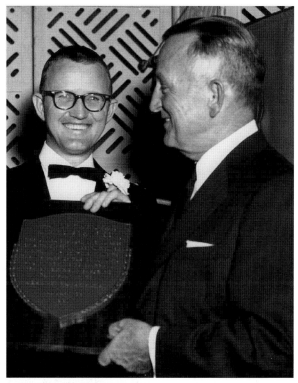

A 1950 graduate of Amherst College, Dan Galbreath, son of Pirates owner John Galbreath, would become an integral part of the front office. After Pittsburgh won its fifth world championship in 1979, his father stepped down and named Dan his successor as president of the club.

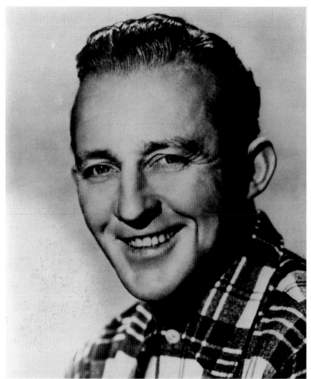

An Academy Award winner who had almost 300 hit singles, Harry Lillis "Bing" Crosby had another credit to his name: part owner of the Pittsburgh Pirates. Perhaps his greatest contribution to the team was the taping of game seven of the 1960 World Series. In 2010, the tape was uncovered, allowing generations of Pirates fans a chance to finally witness the greatest game in franchise history.

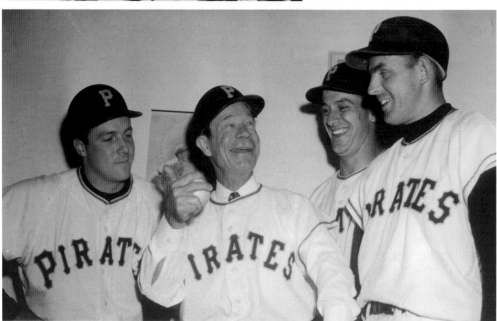

Joe E. Brown was one of the greatest comedians and movie stars of the early part of the 20th century. Brown (second from left) loved the game of baseball, turning down an opportunity to sign with the Yankees when he was younger. He instilled his love of the game in his son Joe Leroy Brown, who would gain notoriety as the general manager of the Pirates.

THE FRONT OFFICE

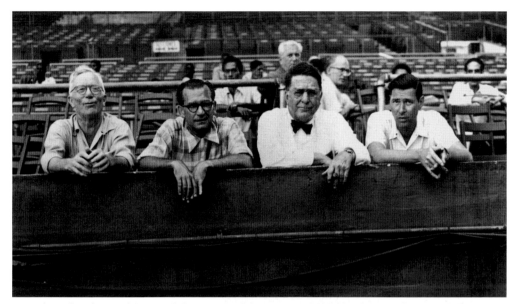

Branch Rickey (second from right) was one of the greatest general managers the game had known. He etched his name in the history of the sport by developing the farm system and by beginning the process of righting an egregious wrong, making Jackie Robinson the first African American in the 20th century to sign a major-league contract, on October 23, 1945.

By the close of the 1940s, Rickey's tenure with the Brooklyn Dodgers seemed to be coming to an end. Following the 1950 campaign, he was forced out by owner Walter O'Malley. Soon after his exit from the Dodgers, the Pirates ownership group quickly signed the GM in an attempt to turn around the franchise's fortunes.

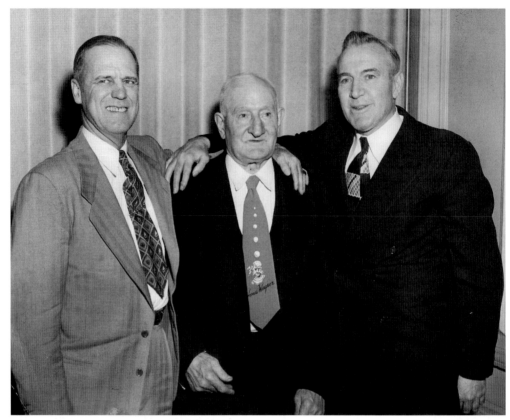

The forgotten members of the 1960 Pittsburgh Pirates were special front office advisor and scout George Sisler and pitching coach Bill Burwell. In the above photograph, Sisler (left) poses with Honus Wagner (center) and Pie Traynor. Sisler, a .340 career hitter who was elected to the National Baseball Hall of Fame in 1939, had been a confidant of Branch Rickey with both the St. Louis Cardinals and the Brooklyn Dodgers before coming to Pittsburgh. He was credited with helping Roberto Clemente win his first batting title in 1961 by suggesting he use a heavier bat. Burwell (left) had managed the Bucs for one game in 1947, replacing Billy Herman. He was a pitching coach with the team in 1947–1948, 1952–1954, and 1958–1962. Burwell reportedly taught Vern Law to more effectively change speeds and throw a change-up while in the minors.

THE FRONT OFFICE

Shown here are United States Steel CEO and member of the team's board of directors, Benjamin Fairless (left), Pirates manager Fred Haney (center), and co-owner John Galbreath. Haney had a horrendous run as Pirates manager between 1953 and 1955, losing over 100 games twice. His replacement, Bobby Bragan, did no better in his one-plus seasons. Then, Danny Murtaugh was given the job and turned the team around.

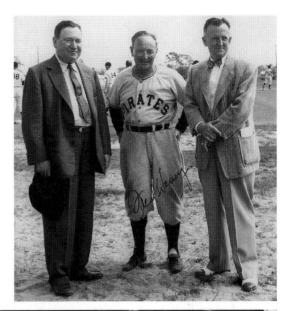

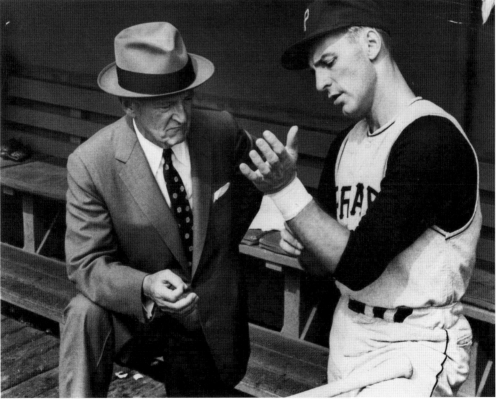

Owner John Galbreath looks on as shortstop Dick Groat shows him his wrist. Pirates fans, owners, and players held their breath when the soon-to-be MVP broke his wrist on September 6. Braves pitcher Lew Burdette hit him with a pitch. After missing the better part of the month, Groat was back in the lineup in time for the World Series.

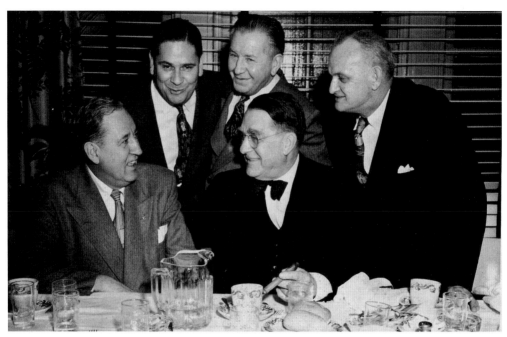

Among those in the above photograph are Branch Rickey (seated at right above and at lower left below) and co-owner Tom Johnson (far right). While Rickey was not there when the Pirates began to win in the late 1950s, his moves would provide some of the key players for the 1960 world champs. He was criticized in the city for trading the team's top box-office star, future hall of famer Ralph Kiner, in 1953. But, Rickey did some great things as well, picking up Roy Face in the Rule 5 draft from the Dodgers in 1952 and signing Bill Mazeroski and Dick Groat. In 1954, he made arguably the greatest move in franchise history, signing Roberto Clemente from Brooklyn in the Rule 5 draft.

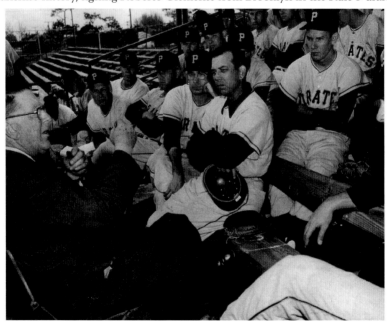

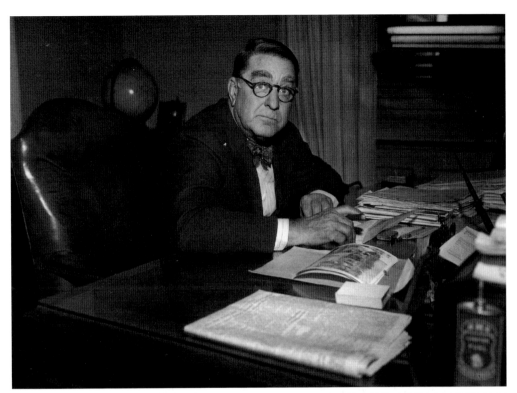

By 1955, the Pirates were still mired in the bottom of the National League. Not having the same success he had enjoyed with both the Cardinals and Dodgers, Rickey left his post with the Bucs. He teamed up four years later with a potential new major league, the Continental League, which helped force expansion in baseball. He ended his career as an advisor with the Cardinals in the early 1960s.

After making a splash by hiring the great Branch Rickey in 1950, the Pirates went in a different direction when hiring his replacement in 1955. The group tapped the little-known general manager of the New Orleans Pelicans, Joe L. Brown, to run the show in Pittsburgh. Within five years, the hiring would prove to be one of the ownership group's greatest moves.

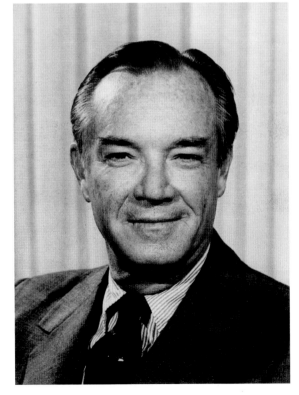

With a big job in front of him to retool the floundering Pirates franchise, new general manager Joe L. Brown (left) needed to find someone to run the team from the dugout, to replace the deposed Fred Haney. His first choice was Bobby Bragan, who, as a player, was part of a group that did not want to play with Jackie Robinson. (Bragan later became a friend of Robinson's.) Bragan won just 66 games in 1956 before going 36-67 in 1957, after which he was relieved of his job. Brown's next selection was former Phillies and Pirates second baseman Danny Murtaugh (below), who had managed the New Orleans Pelicans when Brown was there.

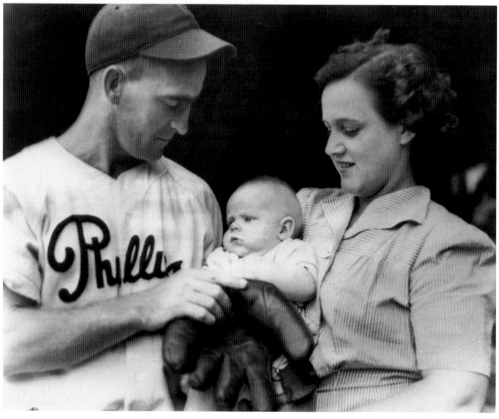

THE FRONT OFFICE

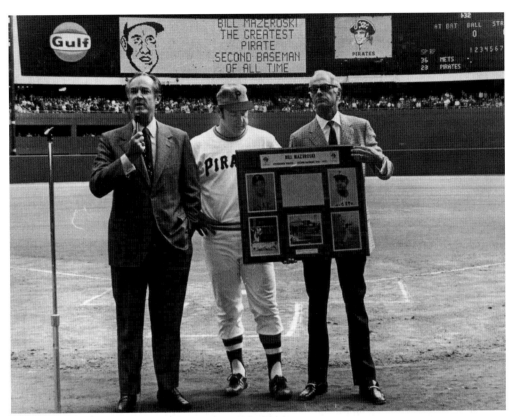

In a ceremony at Three Rivers Stadium in 1972, general manager Joe L. Brown (left) and Pirates announcer Bob Prince (right) present a plaque to Bill Mazeroski at the end of Maz's last season. Unlike 1960, it was a forgettable season for Maz, who had only 64 at bats and hit .188.

Many men occupied the Pirates' announcing booth in the history of the franchise, but none were greater than Bob Prince. Coming up with such memorable calls as "kiss it goodbye," "by a gnat's eyelash," and "chicken on the hill with Will," Prince had a wonderful career between 1947 and 1975 before he was unceremoniously fired. "The Gunner" triumphantly returned to the booth in 1985, sadly dying of cancer only months later.

Known mainly as a news anchor on WTAE-TV between 1969 and 1994, Paul Long was a member of the Pirates broadcasting team from 1957 to 1962. Long, also an airplane pilot, miraculously walked away from a crash in 1962 after flying in from New York, where he had been calling a Bucs game against the Mets at the Polo Grounds.

Sharing a lighter moment at spring training are Pirates announcer Bob Prince (seated, left) and manager Danny Murtaugh. After taking over the team for the last third of the season in 1957, Murtaugh showed he was the right man for the job, leading Pittsburgh to a 26-25 mark to end the season.

THE FRONT OFFICE

Before manager Danny Murtaugh turned around the fortunes of the Pittsburgh club, he was a major-league second baseman. At right, he is seen making a fine play in the field as a member of the Philadelphia Phillies. Below, Murtaugh, in his tenure with the Pirates, slides safely home during a game. He started for three years for the Phillies, his first three seasons in the league, before missing the 1944 and 1945 campaigns due to the war. He returned in 1946, batting only 19 times, before spending 1947 with the Boston Braves, were he went one for nine. His career took a turn upward when he was traded to the Pirates in 1948. He hit .290 and .294 in 1948 and 1950, respectively. Murtaugh retired after the 1951 campaign, when he hit .199.

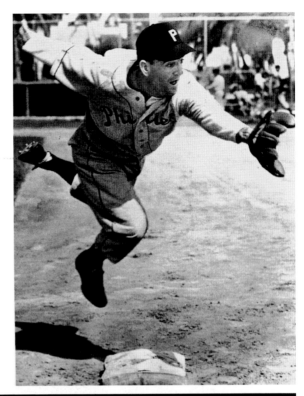

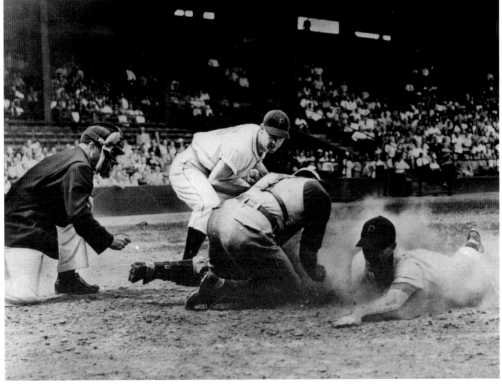

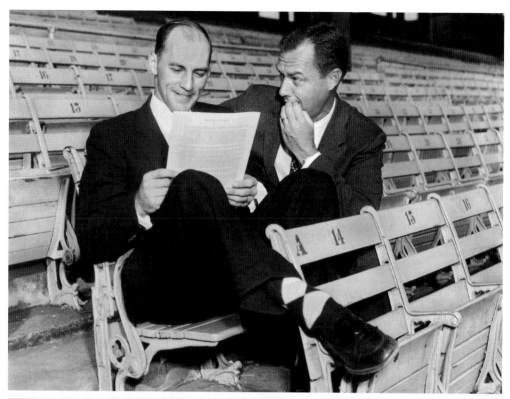

Sharing a light moment, general manager Joe L. Brown (right) shows shortstop Dick Groat his new contract. In 1960, Brown (left) inherited such stalwarts as Vern Law, Bob Friend, Roy Face, Dick Groat, Bill Mazeroski, and Roberto Clemente, but he made many trades that helped turn the Pirates from contenders to world champions. Among the pieces of the 1960 club Brown was responsible for were Bill Virdon, Smoky Burgess, Harvey Haddix, Vinegar Bend Mizell, Don Hoak, and World Series near-hero Hal Smith.

A pivotal part of the front-office team during the Galbreath family's ownership of the Pirates was John Galbreath's son Dan. The younger Galbreath (at left above), a graduate of Amherst, also had a degree from the graduate school at Ohio State University, to which the family had given so much. In fact, the building that houses the Ohio State veterinary school's equine research department is named after Dan Galbreath. Along with being a member of the Bucs executive team, Dan Galbreath ran the family business, the Galbreath Company; was a member of the board of the Federal Reserve Bank; and was the director of Churchill Downs and the National Football Foundation. Unfortunately, Dan (right) died of cancer in 1995 at the young age of 67.

After surprising the baseball world in his short stint as the manager of the Pirates in 1957, Danny Murtaugh showed that the team's performance in the latter half of the season was no fluke. In 1958, they had their first winning record since 1948, finishing 84-70. The second-place Pirates ended the season eight games behind the eventual NL champions, the Milwaukee Braves.

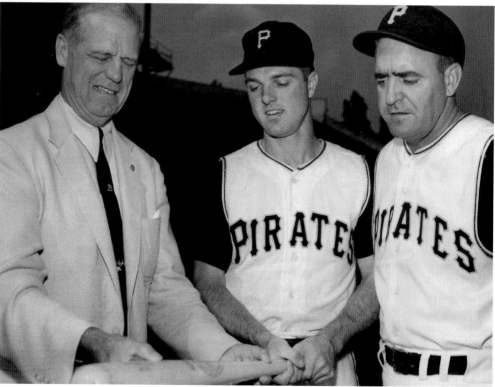

Pirates scout George Sisler held the major-league record for hits in a season, with 257 in 1920. The record held until Ichiro Suzuki broke it 84 years later. Sisler (left), shown with infielder Dick Schofield (center) and manager Danny Murtaugh, had his minor-league contract purchased by the Pirates in 1911, but his potential career with Pittsburgh came to a swift end when the contract was voided.

THE FRONT OFFICE

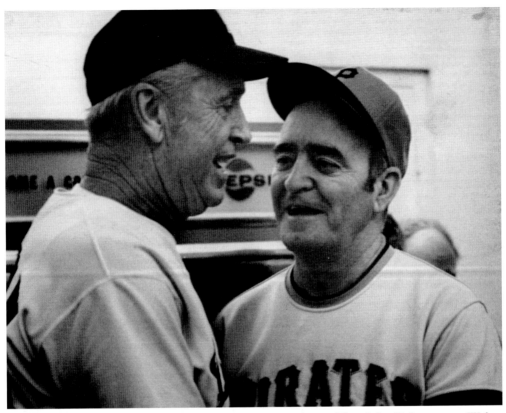

Pictured here are two of the greatest managers during the middle of the 20th century, Walter Alston (left) and Danny Murtaugh. Alston did what no other Brooklyn manager had done, leading the Dodgers to a world championship in 1955, a year after he took over. While Murtaugh could not match that rapid progress, he still won his first championship in a fast manner, two and a half years after being hired.

Apparently unhappy with an umpiring decision, Pirates manager Danny Murtaugh (40) argues a call. Murtaugh had much happier times in 1960. Not only did he lead the team to their third world championship, but he garnered the first of two *Sporting News* Manager of the Year awards.

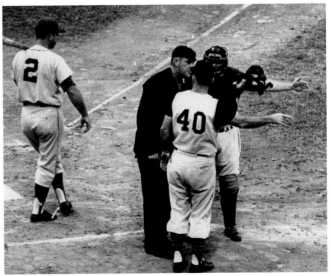

THE PITTSBURGH PIRATES' 1960 SEASON

While he is known in the Steel City as the face of the ownership group of the Pittsburgh Pirates for five decades, John Galbreath was more famous in the sporting world as one of the nation's most successful horse owners. In 1935, he purchased Darby Dan Farms (named after the Darby Creek, which ran near the farm). Along with his son Dan, John Galbreath (at left below with his wife, Dorothy) developed a horse-breeding farm that produced Kentucky Derby winners Chateaugay and Proud Clarion, Preakness and Belmont Stakes winner Little Current, as well as a horse, Roberto, named after the greatest Pirates player in his tenure. The horse won the Epson Derby in 1972.

John Galbreath (center) was important to so many people; it is difficult to say who appreciated his various ventures more. He said horse racing was his first love, even supervising the construction of the Aqueduct racetrack. His philanthropic ventures for Ohio State University athletics were numerous; he was a major participant in recruiting Jerry Lucas to the school, who helped it win the championship in 1960. Galbreath was the chairman of Churchill Downs and the Greater New York Association. To the Steel City, he gave no greater gift than the 1960 World Series championship, a title that came after nothing but failure for the franchise over the first decade and a half of his ownership. The Ohio State alumnus was eventually at the helm of three world titles in Pittsburgh, but none were better than the first. The family held on to the team until 1985. Galbreath died three years later of a heart attack, in 1988.

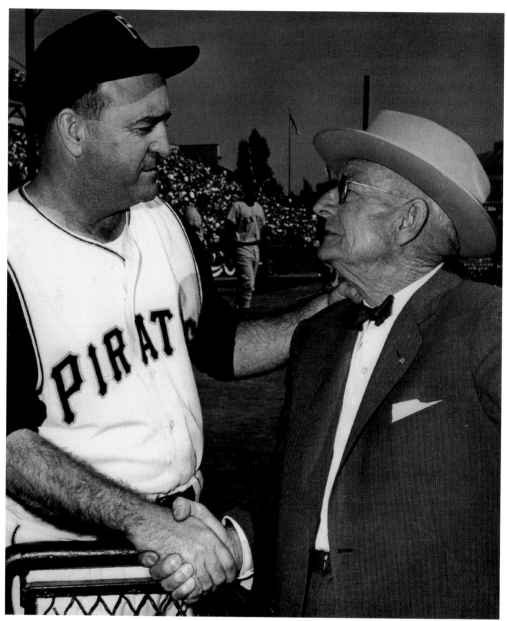

In 35 years, between 1925 and 1960, only two men could make the claim to have led the Pittsburgh Pirates to World Series titles, Danny Murtaugh (left) and Bill McKechnie, pictured here at the 1960 World Series. Born in nearby Wilkinsburg, McKechnie took over the reigns of the Bucs in 1922 and led them to their first NL pennant in 16 years, in 1925. Facing the defending world-champion Washington Senators, the Pirates battled back from a three-games-to one deficit to force a seventh game. Not unlike the deciding game in 1960, Pittsburgh found themselves down, 6-3 at one point, and 7-6 in the eighth. They scored three times in the bottom of the eighth to win 9-7 in a contest that was arguably the greatest in franchise history—that is, until Mazeroski smashed a home run against the Yankees in the ninth inning almost 35 years to the day later.

3

THE PLAYERS

TEAM LEADERS

OFFENSE
Home Runs: Dick Stuart, 23
RBIs: Roberto Clemente, 94
Average: Dick Groat, .325
Doubles: Bob Skinner, 33
Triples: Don Hoak, 9
Stolen Bases: Bob Skinner, 11
OBP: Dick Groat, .371
Slugging Pct.: Dick Stuart, .479
OPS: Don Hoak, .810

PITCHING
Wins: Vern Law, 20
Losses: Harvey Haddix, 10
Saves: Roy Face, 24
ERA: Bob Friend, 3.00 (starter), Clem Labine, 1.48 (reliever)
Winning Percentage: Vinegar Bend Mizell, .722
Strikeouts: Bob Friend, 183
Walks: Vinegar Bend Mizell, 46
WHIP: Vern Law, 1.126 (starter), Roy Face, 1.064 (reliever)

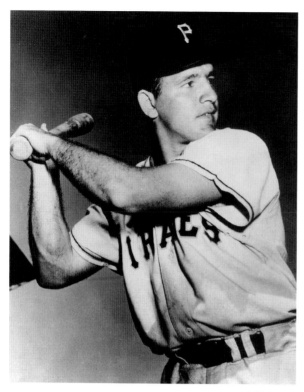

While they did not stay long enough to enjoy the fruits of a world championship in 1960, two local boys played for the Pirates in the mid-1950s. Bobby Del Greco (left) never lived up to his potential, and was sent to the St. Louis Cardinals in 1956. Bob Purkey (below) also was ineffective early on before having a decent season in 1957. Both players were involved in trades for players who won a ring in 1960. Joe L. Brown's trade of Purkey was not good. Purkey ended up with a 103-76 record with the Reds, while the Pirates' acquisition, Don Gross, won just six games. Brown's trade of Del Greco to St. Louis was more beneficial, receiving 1960 starting centerfielder Bill Virdon in exchange.

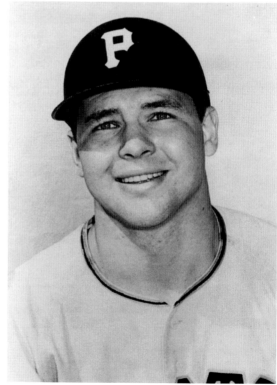

Coming out of West Plains, Missouri, William Charles Virdon was signed by the New York Yankees after playing at Drury University in 1950. Virdon never had the chance to play in Yankee Stadium, as he was dealt to the St. Louis Cardinals in 1954 as part of a three-for-one deal that saw Enos Slaughter sent to New York. It turned out to be a one-sided deal; Virdon hit .281 with 17 home runs while being named the NL Rookie of the Year in 1955. After slipping to .211 early in the 1956 campaign, Virdon was inexplicably traded to the Pirates for Bobby Del Greco and Dick Littlefield. As great as the trade to St. Louis had been for the centerfielder, Virdon's move to Pittsburgh was even better. He hit .334 the rest of the season and became a fixture in centerfield for a decade.

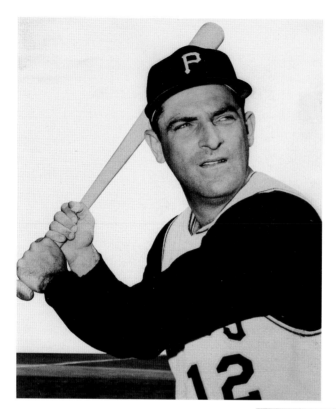

Born in nearby Wheeling, West Virginia, Gene Freese was signed by the Bucs as an amateur free agent in 1953. After a fine rookie campaign in which he hit 14 home runs in 1955, Freese began to slip. While he did not play on the team in 1960, his major contribution to that club was when Joe L. Brown sent him to the Cardinals in 1958 for Dick Schofield.

One of the greatest players ever to pitch in the Dominican Republic leagues, capturing the MVP award six times, Diomedes Olivo never had a true opportunity to see if his game would translate to the major leagues. He pitched for the Pirates in 1960 at the age of 41. Appearing in only four games that year, Olivo became the second-oldest rookie in league history.

THE PLAYERS

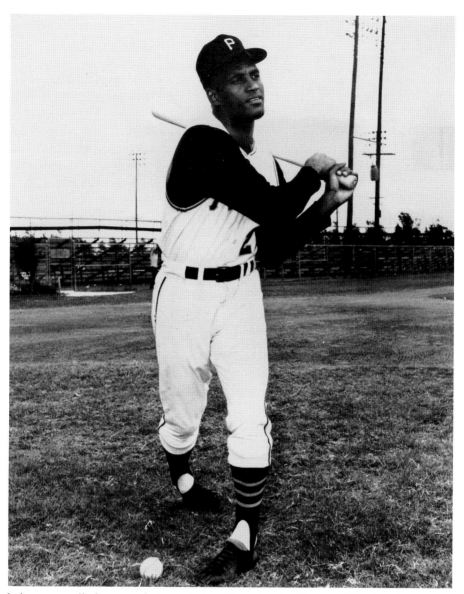

While he eventually became the most beloved icon in the history of Pittsburgh sports, in the early 1950s, no one could have imagined that Roberto Clemente would even become a Pittsburgh Pirate. In the 1950s, there was a rule that if you spent $4,000 or more signing an amateur prospect, they had to be on your major-league roster for two seasons. Most teams were unwilling to take a gamble on the young Puerto Rican with that kind of bonus. Enter the Brooklyn Dodgers, who gave Clemente more than the minimum. While it was done partly to keep the young player out of the Giants outfield with Willie Mays, the Dodgers also did not have room for him on their impressive roster. They tried to hide Clemente on their minor-league club in Montreal, but to no avail. Pirates scouts Clyde Sukeforth and Howie Haak were looking at veteran pitcher Joe Black when they saw Clemente. That off-season, the Pirates drafted Clemente in the Rule 5 draft, and the rest is history.

Signed by the Brooklyn Dodgers as an amateur free agent in 1945, sinker-baller Clem Labine became one of the National League's premier relief pitchers in the 1950s. After finishing third in the Rookie of the Year voting in 1951, Labine enjoyed his best season in the historic 1955 campaign, when he helped lead the Dodgers to their first world championship, with a 13-5 mark and 11 saves. He led the senior circuit in saves over the next two seasons, but began to be ineffective in 1958. Labine was dealt to the Tigers two years later, before Joe L. Brown signed him during the stretch drive in 1960 after Detroit released him. Labine was great for the Bucs, with a 3-0 mark and 1.48 ERA for the champs. He ended his career in 1962 with the Mets.

The modern-day Rule 5 rarely if ever has franchise-altering ramifications. In the 1950s, however, it not only redefined the direction the Pirates were going, but played a big part in the construction of the 1960 team. While the most famous Rule 5 selection was Roberto Clemente in 1954, a lesser-known choice two years earlier was almost as important to the future of the team. That year, the Bucs drafted a minor-league pitcher out of the Brooklyn Dodgers organization by the name of Roy Face (left), arguably the best relief pitcher in Pirates history. A reliever/starter his first two seasons, Face had only mixed results. By 1956, however, he was primarily coming out of the bullpen. In 1958, he was among the best in the game, leading the NL with 20 saves.

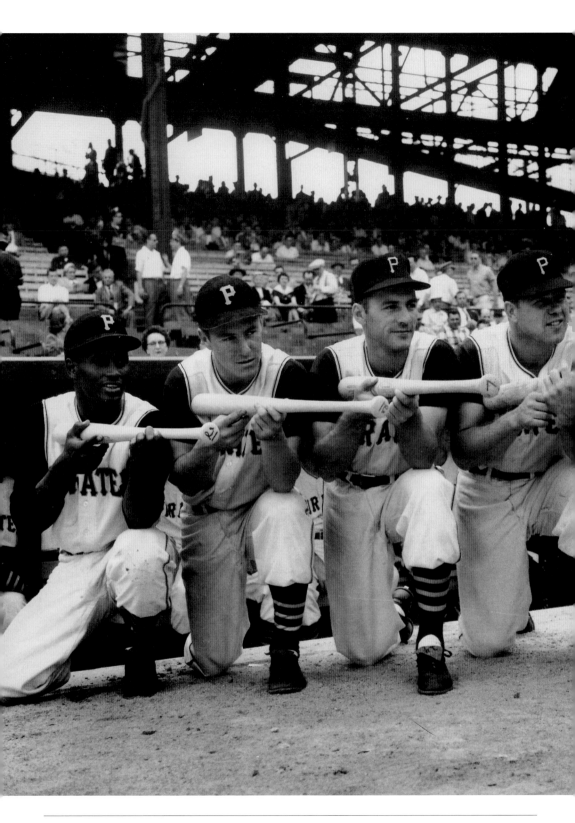

THE PLAYERS

Important parts of the lethal 1960 Pirates offense are, from left to right, Roberto Clemente, Bill Mazeroski, Dick Stuart, Gino Cimoli, and Hal Smith. While Cimoli was homerless in 1960, the other four combined for 61 of the team's 120 long balls that championship season. The potent Pirates offense led the league in runs scored (734), hits (1,493), doubles (236), RBIs (689), on-base percentage (.335), on-base plus slugging percentage (.743), and batting average (.276, a full 11 points over the second-place Braves). It was an impressive performance that led the Bucs to 95 wins, seven games ahead of the Milwaukee Braves at the end of the season.

A catcher from Preston, Iowa, Bob Oldis was inked to a contract by the Washington Senators in 1949. He made his major-league debut four years later, before being sold to the Yankees in 1956. He labored in the minors the next four seasons and then was selected by the Pirates in the 1959 Rule 5 draft. He played sparingly for the Pirates in 1960, hitting .200 in 20 at bats.

Originally signed by the Milwaukee Braves in 1957, Jim Umbricht came to the Pirates in a minor-league deal in 1959 for Emil Panko. He made his MLB debut that year, a late-season start against the Reds, giving up five runs in seven innings of work. Umbricht pitched more extensively in 1960, working 17 games, 14 in relief. He was 1-2 with a 5.09 ERA.

THE PLAYERS

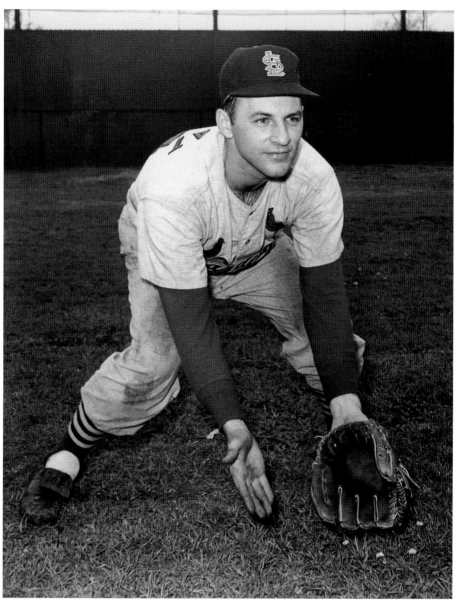

He would go on to be named the 1960 MVP, leading the league in hitting. But, eight years earlier, it was not a certainty that Dick Groat would even play baseball professionally, nevertheless be a pivotal part of two world-championship squads (he was also on the 1964 Cardinals World Series winners). At Duke, Groat was not only a fine baseball player, but exceptional at basketball. He was a first team All-American his senior season, as well as the UPI National Basketball Player of the Year in 1951. He was selected as the third player overall by the Fort Wayne Pistons, scoring 11.9 points per game in his only NBA season (1952–1953). Luckily, he also had signed a contract with the Pirates in 1952, playing 95 games that year, and chose to be a full-time baseball player the year after. Groat eventually had his No. 10 retired at Duke, the first player to have that honor, and has been elected to both the college basketball and baseball halls of fame.

THE PITTSBURGH PIRATES' 1960 SEASON

Signed by the Pirates organization in 1952, southpaw Fred Green finally made his major-league debut with the club after a seven-year minor league career that saw him have some successful seasons, including a 20-win season at Brunswick in 1952. Green was an important part of the Pirates bullpen in 1960, going 8-4 in 45 appearances with a 3.21 ERA and three saves.

An outfielder from the Virgin Islands, Joe Christopher was signed by the Pirates in 1955. He was hitless in 12 at bats his first major-league season (1959). He played little in 1960, hitting .232 with a homer in 56 at bats. He eventually ended up with the expansion Mets in 1962 and had his best season two years later, when he smacked 16 home runs and hit .300.

After serving in the military during the Korean conflict in 1952 and 1953, Bob Skinner had a decent rookie season at only 22 years old in 1954, hitting eight homers with a .249 average. The La Jolla, California, native would soon become one of the best hitters on some bad Pirates teams in the 1950s. Skinner topped the .300 plateau for the first time in 1957 before having one of his best seasons a year later, when the Bucs shocked the National League with a second-place finish. Skinner hit a career-high .321 in 1958, good enough for fifth in the league, while also finishing fifth in OBP with a .387 mark and seventh in OPS at .879. Skinner's great season resulted in him finishing 15th in the MVP election and being selected to play in his first of three all-star games.

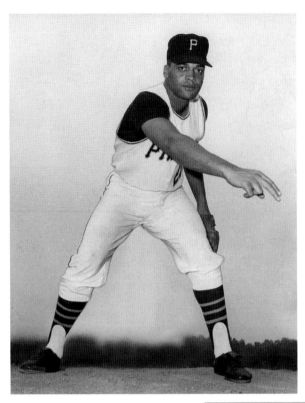

Born in Slab Fork, West Virginia, right-hander Earl Francis had an opportunity to contribute to the 1960 Pirates out of the bullpen. By midseason, manager Danny Murtaugh was looking for some right-handed help to go with Roy Face. The Pirates called up Francis, who was having a fine season at Columbus. He seemed to be the option the Pirates manager wanted, earning a 2.00 ERA in seven appearances. On July 27, he left the game with a sore arm and did not pitch for the Pirates the rest of the season. Francis rebounded and, by 1963, was the opening-day starter for the Bucs against the Reds. He was the first pitcher to face the rookie Pete Rose, allowing a walk to Rose in his first plate appearance.

Signed by the Pittsburgh Pirates as an amateur free agent in 1948 out of Meridian High School in Indiana, Vern Law was not an easy acquisition for the Bucs. Co-owner Bing Crosby had to convince the young hurler to sign. Within two seasons, he was in the starting rotation for the Pirates before leaving the club in 1952 and 1953 to serve in the military during the Korean War. When Law returned, he was back in the rotation and, in 1955, showed a glimpse of just how good he was going to be, winning 10 games for the first time. In 1957, he repeated the 10-win performance and enjoyed his first sub-3.00 ERA mark. While Law had been impressive, the heights he would eventually rise to by 1960 could not have been projected at that time.

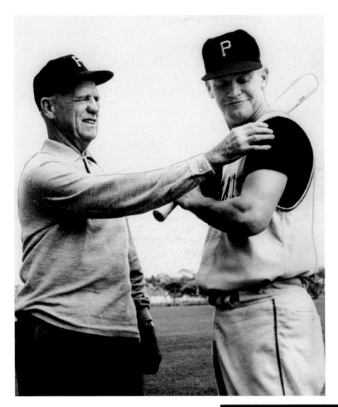

Pictured with scout George Sisler (left), Pirates third baseman Don Hoak was one of the most important pieces general manager Joe L. Brown added as he attempted to trade for talent to complement his young squad. Hoak had enjoyed a solid career with the Dodgers, Cubs, and Reds when, in January 1959, Brown sent Whammy Douglas, Jim Pendleton, John Powers, and Frank Thomas to Cincinnati for him, Smoky Burgess, and Harvey Haddix.

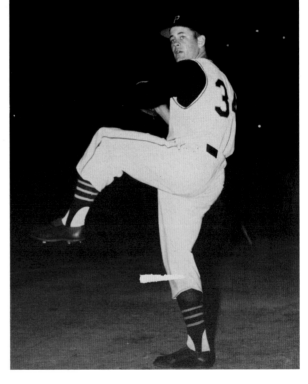

A bonus baby with the New York Giants, Paul Giel had an impressive rookie season with the Giants in 1955 out of the bullpen. He then served in the military in 1956 and 1957. By 1959, Giel was put on waivers by the Giants and picked up by Brown. While 2-0 for Pittsburgh in 1960, he had been ineffective in 16 appearances, with a 5.73 ERA.

Signed out of Purdue University in 1949, Bob Friend spent the first part of his career suffering from a combination of bad luck and a poor team that provided little run support. In the rotation at the young age of 20, Friend won only 28 games in his first four seasons and lost 50. Finally, in 1955, Friend showed Pirates fans, as well as baseball aficionados in general, just how special a pitcher he was going to be. He went 14-9 that season and led the National League in ERA with a 2.83 mark. The next two seasons, he topped the league in both games started and innings pitched while sporting a very mediocre 31-35 record. His losing record was more a reflection of the poor teams he played on than a measure of Friend's ineffectiveness.

A backup catcher with the Pirates, Danny Kravitz hit only .240 in 371 at bats with the team between 1956 and 1959. Perhaps the highlight of his career happened in spring training in 1960, catching a no-hitter against the Tigers. The regular season was not kind to Kravitz, who went hitless in six at bats before being traded to Kansas City on June 1 for Hank Foiles.

A right-handed hurler out of Long Beach State, George "Red" Witt proved to be an effective reliever for the Pirates in the late 1950s. He had an 18-7 mark for Hollywood in 1957 before getting a call to the majors. Witt was 9-2 with a 1.61 ERA in 1958. Unfortunately, he hurt his arm in 1959 and was never the same, going 1-10 with the Bucs between 1959 and 1961.

THE PLAYERS

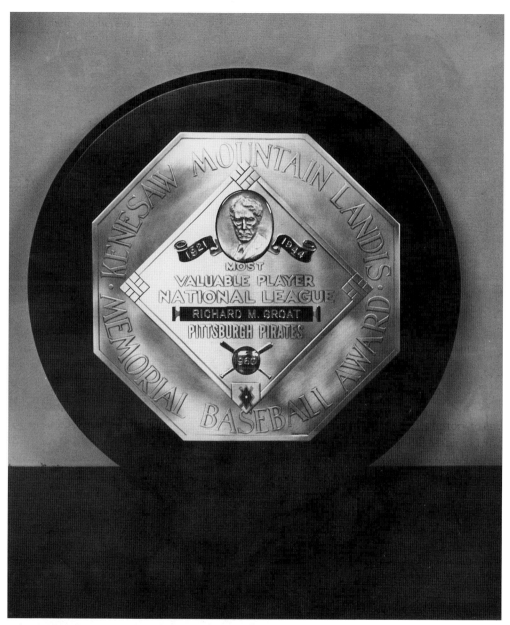

It began in 1911, when Major League Baseball decided to honor the best player in each league as the MVP. Hugh Chalmers, who owned the Chalmers Automobile Company, sponsored the first award, which was won by Detroit's Ty Cobb and the Chicago Cubs outfielder Frank Schulte. Chalmers ended the award in 1914, but the AL reinstated it in 1922, with the NL following two years later. Pirate Paul Waner captured the award in 1927. By 1931, the Baseball Writers' Association of America took over the award, naming the plaque that is given the recipient in 1944 after the famed commissioner Kenesaw Mountain Landis, who passed away earlier that year. The Landis trophy was something that was rarely given to anyone from Pittsburgh. No Pirate captured an MVP award between 1927 and 1960, when shortstop Dick Groat was given the honor.

Coming over from the St. Louis Cardinals on June 15, 1958, for Gene Freese and Johnny O'Brien, infielder Dick Schofield played a limited role for the Pirates in 1960, playing in only 65 games. It can be said, however, that without his effort in September, the Bucs would have had a much more difficult time capturing their third World Series championship. With soon-to-be MVP Dick Groat down with a broken wrist, Schofield was superb. Between September 6 and October 2, the Springfield, Illinois, native hit .403 with a .481 OBP in 21 games. When Groat came back, Schofield returned to the bench. In the World Series, he went one for three.

THE PLAYERS

Dick Stuart was the ultimate paradox: a great player and powerful slugger who was also considered such a joke of a fielder that he was nicknamed "Dr. Strangeglove." When with the Red Sox, he had a license plate that read "e3," and Boston fans mocked him with a standing ovation when he picked up a hot dog wrapper at Fenway Park. Regardless of his shortcomings, Stuart was an important part of the 1960 Pirates. Signed by the organization in 1951, Stuart had a monster minor-league campaign in 1956, smacking 66 homers. He came up to the majors two years later, immediately showing Bucs management that he could be a successful major-league hitter, with 16 home runs in 254 at bats. Proving it was no fluke, the first baseman smacked 27 in 1959 and had a .297 average.

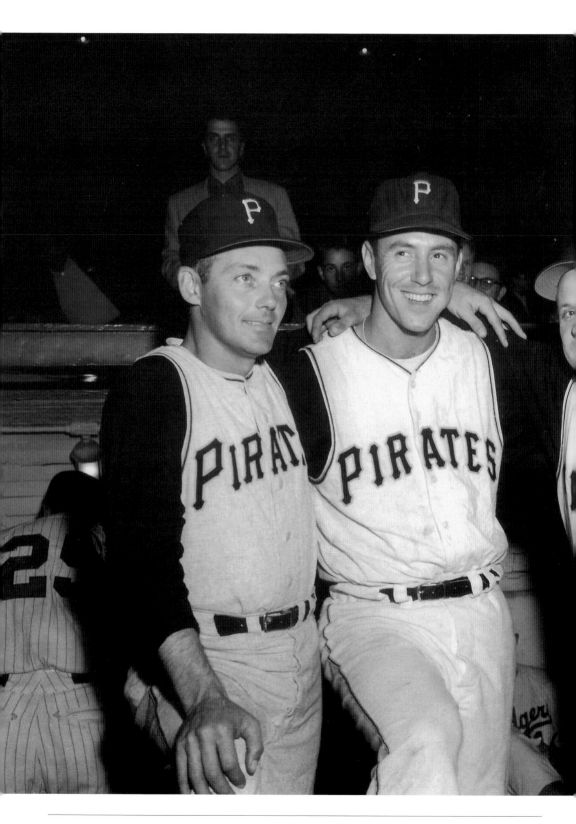

THE PLAYERS

The combination of (from left to right) Roy Face, Bill Mazeroski, and Smoky Burgess was part of the reason the Pirates pitchers were so effective in 1960. Known as one of the greatest pinch-hitters in the history of the game, catcher Burgess also did an effective job handling the hurlers. The pitchers had to be very confident of ground balls up the middle, knowing they had arguably the greatest defensive second baseman in the history of the game in Mazeroski. Finally, Pittsburgh had one of the premiere relievers in the 1950s and 1960s, Roy Face. He led the league three times in saves, making the team confident that a lead in the late innings would turn out to be a win.

Forsaking a basketball scholarship from UCLA, pitcher Bennie Daniels chose to sign with the Pittsburgh Pirates in 1951. He came to the majors in 1957 and was fairly ineffective in his four years in Pittsburgh. Daniels was 1-3 with a 7.81 ERA for the Bucs in 1960. He was sent to Columbus midway in the season.

Coming over to the Pirates from the Reds for Bob Purkey in December 1957, Don Gross had a solid two seasons for Pittsburgh. An arm injury at the end of 1959 lingered in 1960. He made the club out of spring training and was 0-0 with a 3.38 ERA, but the arm was still bad. Gross was sent to the minors, never to return to the majors.

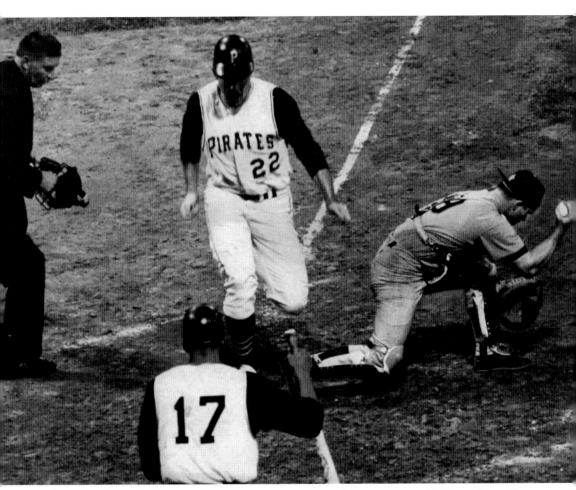

Signed by the Pittsburgh Pirates out of the University of Mississippi in 1957, southpaw Joe Gibbon (22) had three solid seasons in the Pirates farm system, going 31-26 between Lincoln and Columbus, including a solid 16-9 campaign in 1959, when he had a 2.60 ERA. His fabulous 1959 season with the Jets prompted general manager Joe L. Brown to promote him in 1960. Gibbon had a solid rookie campaign, with a 4-2 record and a 4.03 ERA in 27 games, which included nine starts. He had a forgettable first start against the Giants on May 8, giving up four runs, two earned before getting an out. But Gibbon won his second start impressively 11 days later, going seven and one-third innings in an 8-3 victory. Struggling after his win against the Cardinals, Gibbon got revenge against the Giants on June 30, allowing one run over seven and two-thirds innings in an 11-6 win.

A Villanova University alum who had 2,495 hits while batting .286 in 19 seasons when he came to the Pirates in 1960, Mickey Vernon was a great presence on the Bucs bench as a first-base coach in 1960, following his retirement in 1959. He had one last shot as a player in September, when the rosters expanded. Vernon went one for eight.

Cuban-born Roman Mejias was a reserve outfielder with the Pirates in the 1950s. He hit .245 with 17 homers between 1955 and 1959. Mejias began the 1960 season with the Pirates, striking out in his only at bat. Mejias was sent to Columbus by the end of April. He was set to return in September, but his season ended when he suffered a broken arm after being hit by a pitch at Columbus.

THE PLAYERS

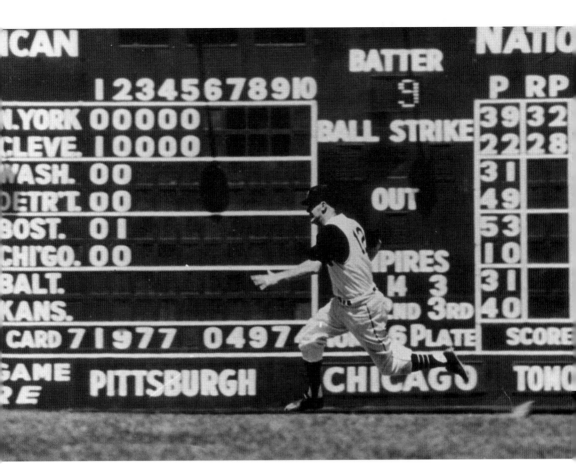

Hailing from Roulette, Pennsylvania, Don Hoak had been a solid third baseman for the Cincinnati Reds when he was acquired by Pittsburgh in January 1959. He had a very solid 1959 campaign for the Bucs, leading the league in games played with 155 while hitting .294 with eight home runs. His efforts were good enough for Hoak to get MVP consideration, finishing 17th in the vote. He continued to be an important part of the Pittsburgh attack during their championship season in 1960, with 16 homers and a .282 average. The third baseman had the ninth-best WAR (wins above replacement) for position players that season (5.4). His 4.6 offensive WAR was also ninth in the league. His fine campaign was good enough for second place in the MVP race, behind the man just to his left on the Pirates infield, shortstop Dick Groat.

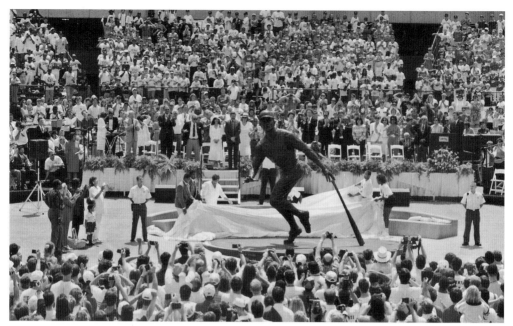

The story of Roberto Clemente is well known, and it easy to see why he is the greatest sports icon ever to grace Pittsburgh. It comes as no surprise, then, that the Pirates honored him with a statue outside the stadium. The only question is, why did it take so long to build a memorial to the Puerto Rican native? The above photograph depicts the statue's dedication ceremony outside Three Rivers Stadium before the 1994 all-star game. Clemente is the only Pirate to have 3,000 hits in a Pittsburgh uniform. The below photograph shows where the statue resides now, outside the left field gate at PNC Park. It was moved there when Three Rivers was demolished and PNC was opened. (Above, courtesy of the Pittsburgh Pirates; below, courtesy of David Finoli.)

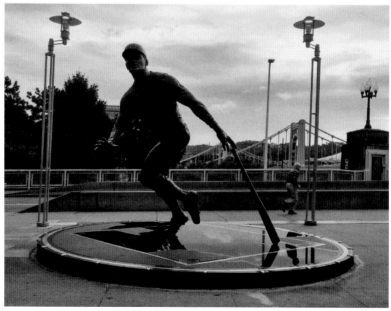

THE PLAYERS

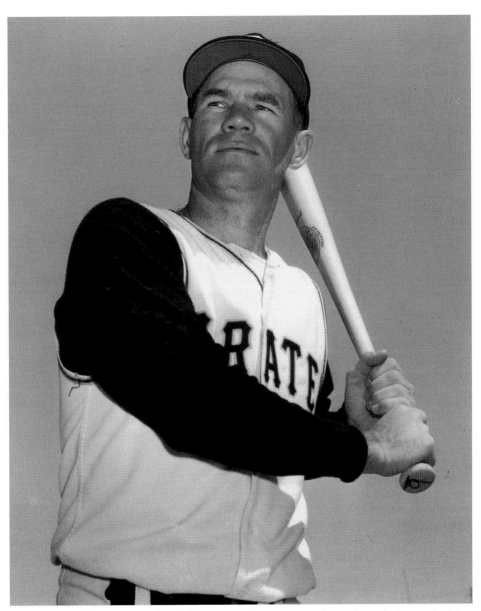

A veteran of World War II, Rocky Nelson spent three years in the military before embarking on his professional baseball career. While he made the rounds of the majors during the 1950s, playing for the Cardinals, White Sox, Dodgers, Pirates, and Indians, most of his success happened in the minors. He was the International League MVP three times, first with Montreal in 1953, when he hit 34 homers. He won the award again in 1955 with the Royals, this time hitting 36 long balls and compiling a .364 average. His third award came in Toronto in 1958, when he hit .326. His 1958 campaign prompted Pirates general manager Joe L. Brown to select the first baseman in the Rule 5 draft, which proved to be fortuitous for the Bucs. Nelson instantly gave the Pirates a dangerous bench, as he hit .291, a career high at that point, with six homers in 175 at bats. After traveling so much, it was apparent that the 34 year old had finally found a home in the majors.

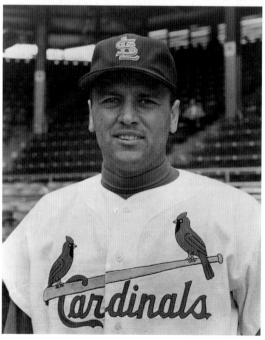

An all-star with the Dodgers, Gino Cimoli came over to the Pirates before the 1960 campaign from St. Louis. Hitting .267 as a reserve outfielder in 1960, Cimoli got his chance to shine when Bob Skinner was hurt in game one of the World Series. Cimoli started the next five games and had a clutch leadoff hit in the eighth inning of game seven that started a five-run outburst. Cimoli remained in Pittsburgh for one more season, hitting .299 in 67 at bats in 1961, before being sent to the Braves in June for Johnny Logan. He ended up with the A's in Kansas City, where he had two solid seasons as a starter in 1962 and 1963. His major league career ended in 1965, when he was hitless in five at bats for the Angels.

THE PLAYERS

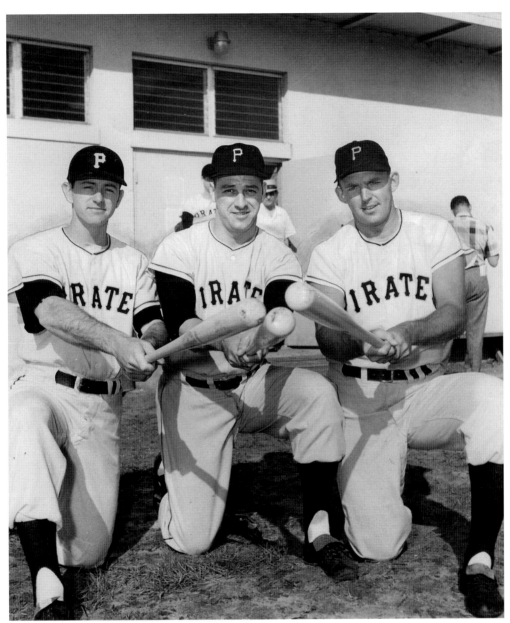

Among the most effective power hitters the Pirates had in the 1950s were (from left to right) Dick Stuart, Dale Long, and Frank Thomas. Long launched 27 homers in 1956, including homering in eight consecutive games, a record that has not been surpassed (tied by Don Mattingly in 1987 and Ken Griffey Jr. in 1993). Thomas, who later liked to call himself the "Original Frank Thomas," played for the Pirates between 1951 and 1958. He hit 163 long balls in that period, including surpassing 30 home runs and 100 RBIs twice. Only Stuart remained by the time 1960 came around, although two of the three players were on the field when the 1960 World Series began. Long played in the series for New York, going one for three, including a single in the ninth inning of game seven, when the Yankees tied the score.

Pirates reliever Roy Face had two incredible seasons in 1959 and 1960. He won a contest on April 22 against the Giants for his first victory of the season. By the time August 30 rolled around and the Bucs defeated the Philadelphia Phillies 7-6, the reliever had earned his 17th victory against no losses. The win was the right-hander's 22nd in a row, in a year when he set the all-time record for winning percentage in a season (.947) and wins in a year for a reliever (18). In 1960, Face (at left below) continued his impressive pitching, with a 10-8 mark and 24 saves. He was selected as an all-star both seasons.

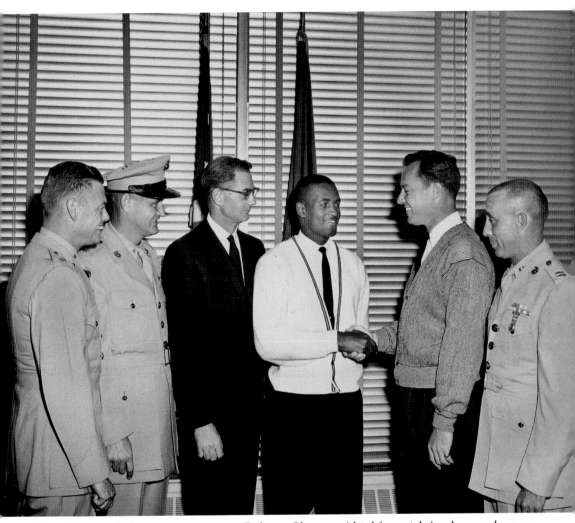

This photograph shows young superstar Roberto Clemente (third from right) as he was about to go into the Marine Reserves. He is joined by Bob Prince (third from left), general manager Joe L. Brown (second from right), and three unidentified Marines. Clemente was set to play winter ball after the conclusion of the 1958 campaign, but instead served in the Marine Reserves. The Latin superstar spent the first part of his military career training at Parris Island in South Carolina before heading to Camp Lejeune. Clemente would serve until 1964, and credited his time in the military with helping him end his chronic back issues, which had plagued him in the years before he served. While at Parris Island, the right fielder did his training with the 346th Platoon; he was an infantryman at Camp Lejeune. In 2003, Clemente was posthumously selected to the Marine Corps Sports Hall of Fame.

Harvey Haddix talks to a group of aspiring young baseball players during the 1981 MLB strike. Nicknamed "Kitten," Haddix had an incredible rookie season for the St. Louis Cardinals in 1953. The Rookie of the Year runner-up had a 20-9 mark and a 3.06 ERA. By 1959, he had not repeated that success, and came to Pittsburgh in a trade with the Reds.

Another member of the 1960 squad who enjoyed reaching out to the youth of the area was Vern Law, pictured here (standing) taking to a group of schoolchildren. By 1959, Law had become one of the better pitchers in the league and gave a sign of what was to come in 1960, with an 18-9 mark and a 2.98 ERA, his first sub-3.00 ERA campaign.

Shown here is the manager of the Pittsburgh Pirates in 1972, former center fielder Bill Virdon. After hitting .334 in 1956 following his trade from the Cardinals, Virdon wanted to show that it was not a fluke. He never reached that lofty batting average again, but the Hazel Park, Michigan, native would prove to be a stable force in the Pirates lineup, hitting .258 between 1957 and 1959, with 25 home runs. While he was not a premier offensive player, what Virdon gave the Bucs was incredible defense in center field. In the spacious Forbes Field outfield, defensive prowess was extremely important, and Virdon gave Pirates pitchers a level of comfort, knowing he was there to run down fly balls. The league would eventually recognize Virdon's incredible defensive skills, awarding him the Gold Glove in 1962.

There were two Hal Smiths who played for Pittsburgh in the 1960s. One, pictured below, went hitless in three at bats in 1965, but the other, pictured at left, etched his name in Pirates lore in 1960. After playing for five years with the Orioles and Kansas City A's, Smith was traded to the Pirates before the 1960 campaign for Dick Hall, Ken Hamlin, and Hank Foiles. Smith had a great year with the Bucs, hitting .295 with 11 homers. His 12th home run, in the bottom of the eighth in the seventh game of the World Series, gave the Bucs a 9-7 lead. It proved to be much more memorable than any of the 11 he hit during the regular season.

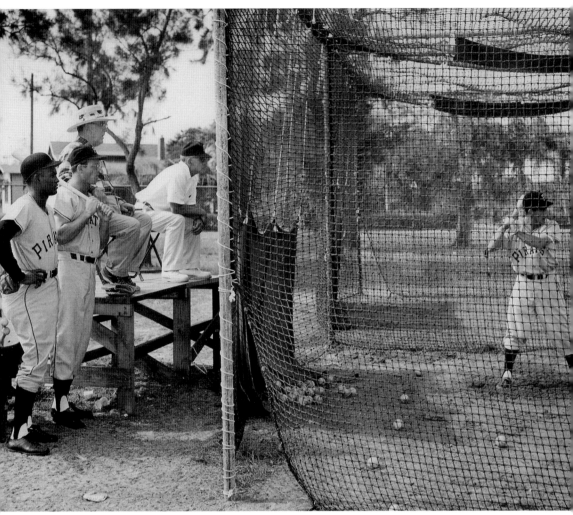

Looking on at spring training batting practice is Roberto Clemente (far left). The Gold Gloves, batting titles, world championships, and MVP were still in his future. At this point, all that Pirates fans knew was that Clemente was a talented player who the front office had pilfered from the Brooklyn Dodgers in the Rule 5 draft after the 1954 campaign. Clemente was given a starting spot in the Pirates outfield in 1955 and, in his second season, began to live up to his promise, exceeding the .300 batting average mark for the first time in 1956, hitting .311. The future hall of famer had a sophomore slump in 1957 with a .253 average, but he quickly rebounded, hitting .289 and .296 in 1958 and 1959, respectively. While 1959 was a good one for Clemente, his .296 average would represent the last time he fell below .300 for eight seasons.

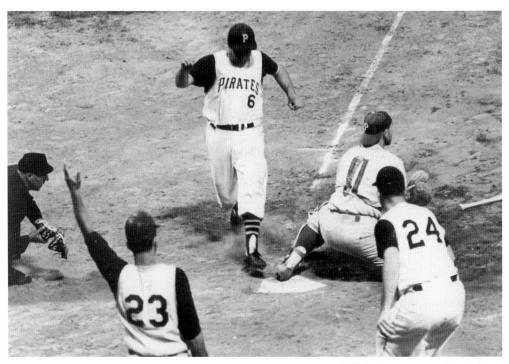

While he was considered the starting catcher for the Pirates for the better part of his career there, including in 1960, when he hit .294, Forrest Harrill "Smoky" Burgess was more famous for another aspect of his game. Burgess was perhaps the greatest pinch-hitter in the game's history. By the time his 18-year career was over, he had amassed a major-league record 145 pinch hits. He was 32 years old when he became a member of the Pirates as part of a very one-sided trade with the Reds, coming over with Don Hoak and Harvey Haddix. In 1960, the trade gave Pittsburgh a very formidable duo behind home plate in terms of offense. Burgess and Hal Smith combined for a .294 average.

After deciding his path in professional sports would be with the Pittsburgh Pirates and major league baseball, local boy Dick Groat had an impressive rookie season in 1952. He served in the military during the Korean War, where he continued to pursue both of his athletic loves, baseball and basketball, playing in the Army. When he returned to the States, it was all about the Pirates, as he resumed his starting spot at shortstop. After seasons of .267 and .273 in 1955 and 1956, respectively, Groat showed what a potential offensive threat he could be the next two seasons. The Wilkinsburg native had a breakout season in 1957, hitting .315 with a career high in home runs (seven). A year later, Groat once again reached the .300 mark, hitting .300 on the nose in 1958 and knocking in 66 runs.

Signed by the Pirates as an amateur free agent in 1954, Bill Mazeroski, from Wheeling, West Virginia, was a 17-year-old, slick-fielding shortstop. No one could have guessed that, in only six short years, the quiet, unassuming kid would turn into one of the greatest heroes the Steel City had ever known. After only a year and a half in the minors, Maz was promoted to the major leagues in June 1956 and immediately took over the starting spot at second base. He never looked back. Known more for his defensive prowess over his 17-year career, Mazeroski also proved to be adept offensively in his first three seasons, hitting .283 and .275 in 1957 and 1958, respectively. While winning his first Gold Glove in 1958, he also showed some power that season, hitting what would be a career-high 19 home runs. This same power would be displayed on October 13, 1960, when he etched his name into Pirates lore.

It was 3:36 p.m. on October 13, 1960. Second baseman Bill Mazeroski came to the plate. He was a young player with a great glove and some pop in his bat, but calling him an icon, a man who would provide the most impressive home run in the long history of the national pastime, was the last thing most would have thought for the 23-year old. Moments later, as the ball flew over the left field fence, giving the Pirates a dramatic 10-9 win in game seven against the powerful New York Yankees, Mazeroski achieved all of the above in a single moment. The monument seen here was installed in the ground by Pirate Charities and the Pittsburgh Parks Conservancy near where the home run cleared the fence. The site celebrates the 50th anniversary of the memorable blast.

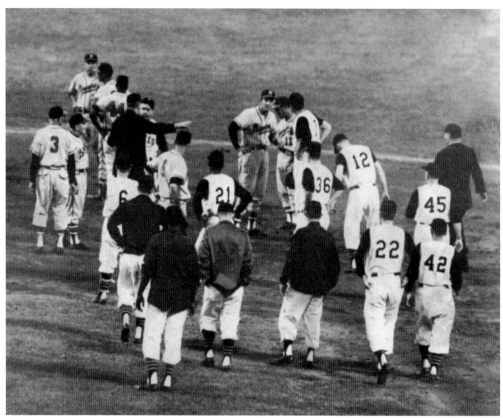

Above, players leave the field on May 26, 1959, after pitcher Harvey Haddix not only threw arguably the greatest game ever pitched, but had his heart broken, all in one moment. Haddix came into the game with a 4-2 record. For 12 innings against the Milwaukee Braves, he did what no man has done before or since, toss 12 perfect innings. In the 13th inning, he lost the perfect game on an error; then, he lost the game and the no-hitter when Joe Adcock smashed a home run that turned into a long double when he passed Hank Aaron on the bases. The Braves won the game 1-0. Haddix (shown at left on a tractor) went on to a solid 12-12 season in 1959 with a 3.13 ERA.

Gene Baker, shown here (at right) being congratulated for his service to the club by Joe L. Brown, may have been a forgotten part of the 1960 Pittsburgh Pirates. He hit only .243 in 37 at bats, but he has a place in the history of baseball and the team. Signed by the Cubs as a shortstop out of the Negro Leagues, Baker, 29, was the first African American to make the Cubs roster. Unfortunately, he was injured, and another Cub, Ernie Banks, became the first to actually play in a game. Baker finished his career in 1961, then was asked to become the first African American manager in organized baseball, heading the Bucs' class D team in Batavia. Eventually coming back to the team as a coach, Baker became the first African American to manage a game in the majors after Danny Murtaugh was kicked out of a contest and suspended for two games in 1962. Baker went on to become the Pirates' top Midwest scout for 23 years.

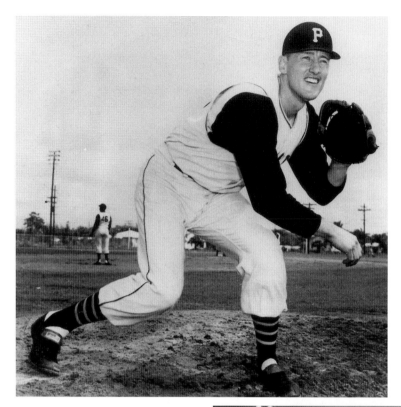

In 1960, Vern Law showed the National League just how dominant a pitcher he could be. He won 20 games for the only time in his career, going 20-9 for an NL third-best .690 winning percentage. It seemed that, any time the Pirates were playing poorly, Law was the tonic they needed to end the losing streak. For his efforts, Law became the first Pirate to win the Cy Young Award.

While Bob Bailey (second from left) never played with the 1960 world champion Pirates, the other three being honored in this 1963 photograph were important parts. Roy Face (far left) won the 1962 Fireman of the Year award, Roberto Clemente (second from right) holds his second of 12 consecutive Gold Gloves, and Bill Virdon poses with his only Gold Glove, won in 1962.

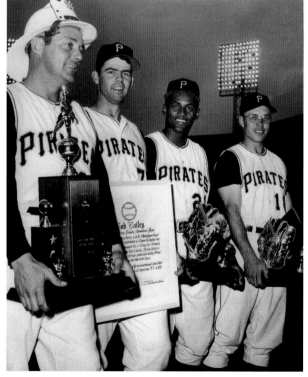

THE PLAYERS

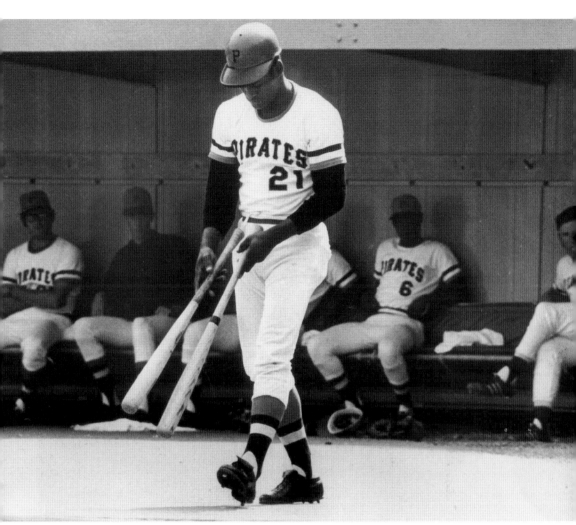

While he would eventually become an icon in Pittsburgh, Roberto Clemente was a 25-year-old right fielder just coming into his own in 1960. He had his breakout season that year, hitting .314 and smacking a then career high 16 home runs while driving in what was also a career high at the time, 94 RBIs. Clemente also had an impressive .459 slugging percentage and .815 OPS, becoming an all-star for the first time. The future hall of famer was upset with his eighth-place finish in the MVP race. Clemente felt he was disrespected by the voters, thinking it was because of his heritage and the color of his skin and not an indication that he was actually the eighth-best player in the league. Because of the slight, Clemente never wore his world championship ring.

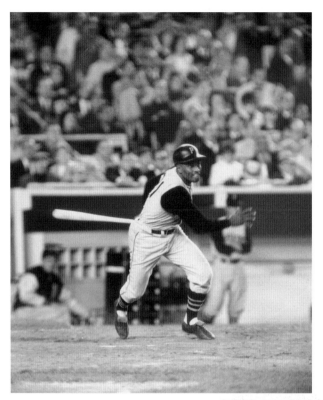

The end of Clemente's life is well noted: his heroic death in a plane crash while trying to deliver supplies to earthquake-ravaged Nicaragua. But his superb play in the early-to-mid 1960s is often forgotten. Following the bitterness of an eighth-place finish in the 1960 MVP race, the Puerto Rican native was inspired to greater things. He broke the 200-hit barrier in 1961 for the first of four times and captured his first batting title (.351). Between 1961 and 1966, he hit .328 with 101 home runs and 1,168 hits. Finally, in 1966, Clemente captured the award he had wanted for so long—the National League's Most Valuable Player.

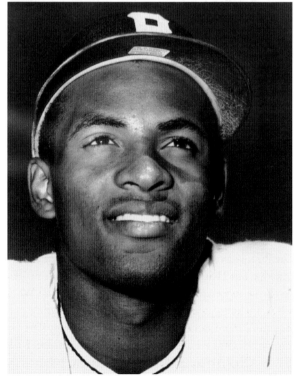

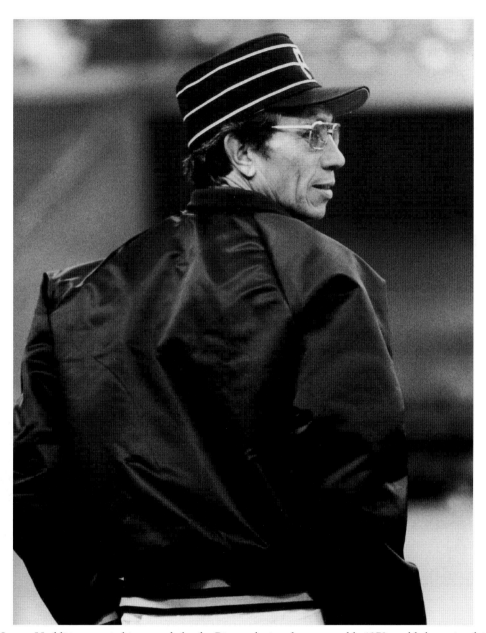

Harvey Haddix was a pitching coach for the Pirates during the memorable 1979 world championship run, and continued in that role until 1984. In 1960, he was an effective left-handed presence in the Pirates rotation. After winning 12 games for the team in 1959 with an NL-best 1.061 WHIP, Haddix was 11-10 with a 3.97 ERA for the club in 1960. He was one of the few Pirates pitchers to throw successfully against the Yankees in the World Series, winning two games with a 2.45 ERA, including winning the seventh and deciding game in a relief appearance. Haddix went on to win 22 more games with the Pirates between 1961 and 1963 before being sent to the Baltimore Orioles in 1964 for a minor leaguer by the name of Richard Yencha. The aging southpaw was 8-7 for the Orioles during his final two seasons before embarking on a coaching career.

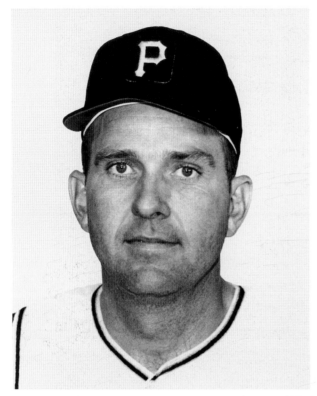

After debuting with the 1960 world champion Pittsburgh Pirates, Joe Gibbon became a member of the starting rotation in 1961. After finishing his sophomore campaign with a 13-10 mark and a 3.32 ERA, the University of Mississippi alum spent the next four seasons in a Pirates uniform, going between the bullpen and starting rotation and combining for a 22-32 record with one save. He was sent to the Giants in 1966 with Ozzie Virgil for Matty Alou, but he returned to Pittsburgh three years later. Gibbon was an effective reliever in 1969 before struggling in 1970. Following his time with the Reds and Astros in 1971 and 1972, Gibbon ended his major-league career with a 61-65 record.

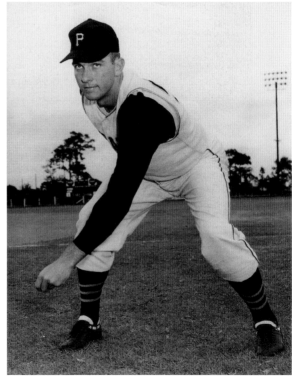

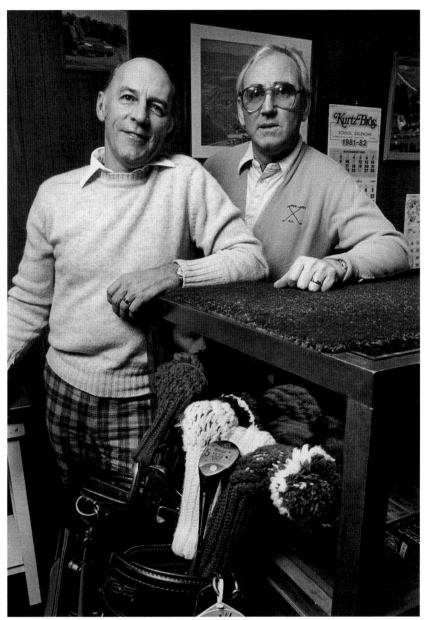

Former Pirates teammates Dick Groat (left) and Jerry Lynch (right) had a dream to open a golf course in the mid-1960s. In 1966, their dream turned into a reality when they established one of the premiere courses in Western Pennsylvania, Champion Lakes. Before becoming a golf course owner, Groat had lived many dreams in 1960: winning a batting title (.325, two points better than Norm Larker of the Dodgers); being named the league's MVP, capturing 16 of the 22 first-place votes despite the fact he missed most of September with a broken wrist; and earning a world championship. The Wilkinsburg native would go on to have two more successful seasons with the Bucs before being shipped off to the Cardinals prior to the 1963 campaign in a trade with Diomedes Olivo for Don Cardwell and Julio Gotay.

In 1958 and 1960, left fielder Bob Skinner was a consistent hitter. While not a base-stealing threat, nonetheless, he was the only player who had double-digit steals for the Pirates in both seasons. Skinner hit .280 and .273 for the team in those seasons, respectively, while belting 13 and 15 homers. While both campaigns were effective, they paled in comparison to his two previous seasons, when he exceeded .300. Skinner's career would never reach those levels again, save for 1962, where he had a career-high 20 homers and hit .302. He was shipped to the Reds a year later in the middle of 1963 for Jim Saul. Skinner returned as a hitting coach for the Pirates in the mid-1970s and was the hitting coach for the 1979 champion Bucs.

THE PLAYERS

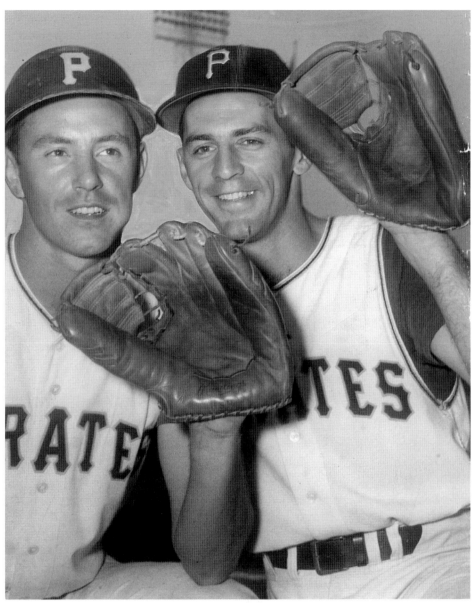

In the late 1950s and early 1960s, there was perhaps no better middle infield than Bill Mazeroski (left) and Dick Groat (right). While Maz was the more celebrated of the two, capturing eight Gold Gloves for his work at second and being selected by the veterans committee to the National Baseball Hall of Fame in 2001, Groat was a fine defender in his own right. Groat had great range, leading the league in defensive WAR in 1960 with a 2.6 mark. He unfortunately never won a Gold Glove. The duo was broken up in 1963 when Groat was sent to St. Louis. He was a great pickup for the Cardinals, leading the league in doubles in 1963 and hitting .319, finishing second in the MVP race. In addition, Groat helped the Cards to a World Series title in 1964. He retired after a season with the Phillies and Giants in 1967 and today is the legendary color man for the University of Pittsburgh basketball team.

There was no better year than 1960 for two native sons of Western Pennsylvania: Wilkinsburg's Dick Groat (left) and Latrobe's Arnie Palmer (right). While Groat captured his only batting title, the National League's MVP, and a world title that year, Palmer's season was even more impressive. After winning his second Masters, the golfer competed in that year's US Open. He found himself seven strokes back, in 15th place, after the third round. Palmer rallied remarkably, with a final round 65, to win his lone US Open title. For his efforts, Palmer was awarded the 1960 Hickok Belt as the nation's top professional athlete, and was named the *Sports Illustrated* Sportsman of the Year.

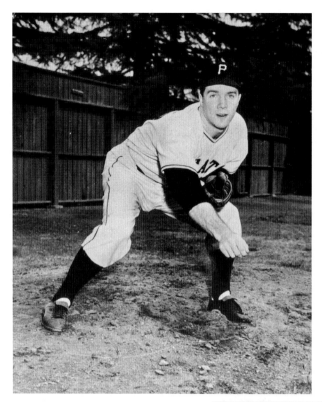

Following his breakout season in 1955, Pirates pitcher Bob Friend was quickly recognized as one of the best pitchers in the National League. He led the circuit in games started the next two seasons, then had his premier campaign in 1958, with an NL-high 22 wins. After slipping to 8-19 in 1959, he returned in 1960 as one of the top hurlers (18-12).

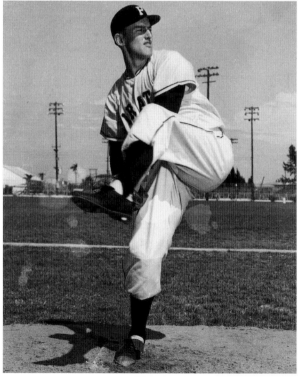

Following his award-winning season in 1960, Vern Law's career quickly went downhill. Injuries curtailed the Cy Young Award winner in 1961, as he started only 10 games and finished 3-4. He never returned to his 1960 form over the next three seasons, and it seemed that his career was over. Law rebounded with a 17-9 mark in 1965, when he was named the Comeback Player of the Year.

THE PLAYERS

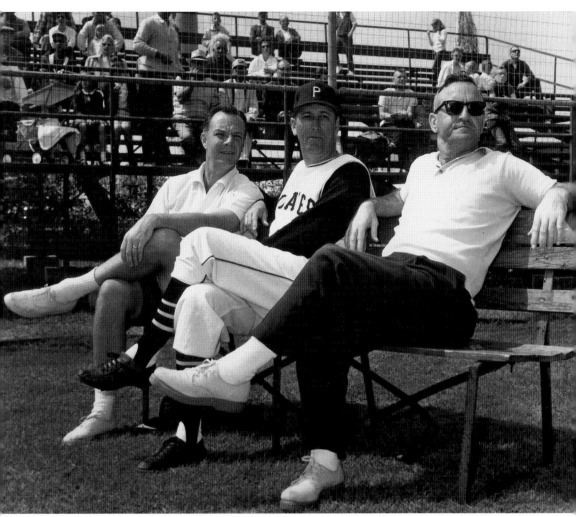

Pictured here is the Pittsburgh Pirates brain trust during the first half of the 1960s. From left to right, Joe L. Brown, Harry Walker, and Danny Murtaugh led the Bucs to successful years during the decade. Following the excitement of the 1960 world championship, Pittsburgh had an injury-ridden 1961, then a superb 93-win campaign in 1962. The team finished under .500 the next two years, and Murtaugh retired after 1964 due to health reasons. Walker took over in 1965 and had back-to-back 90-win seasons in 1965 and 1966. The club struggled in 1967, recording a .500 mark midway during the campaign when Walker was relieved of his job. Brown called on his old friend Murtaugh to finish the season. Afterward, the veteran Bucs manager retired once again, but he returned in 1970 and eventually won his second World Series crown in 1971.

Those who experienced the excitement of the 1960 Pittsburgh Pirates world championship run can call up so many memories to put a smile on their face. Other than the classic home run in the seventh game of the World Series by Bill Mazeroski, perhaps the other most consistent memory was that of the team's anthem, "Beat 'em Bucs," by local jazz star Benny Benack. Born in Clairton, Pennsylvania, Benack played the trumpet and headed the Benny Benack Orchestra, which specialized in jazz, swing, and Dixieland. He wrote the memorable tune, which was on fans' lips all season. "The Bucs are going all the way, all the way, all the way. Yes, the Bucs are going all the way, all the way this year." Thanks to the song, the phrase "Beat 'em Bucs" has been part of Pirate fans' vernacular ever since. Benack unfortunately died of lung cancer in 1986.

Following his phenomenal two-year run in 1959 and 1960, when he was 28-9 with 34 saves, reliever Roy Face (left) settled into his role as one of the first great closers in baseball. He led the league in saves in 1961 and 1962, winning the NL Fireman of the Year in the latter season. He stayed with the team until 1968, finishing with a 100-93 mark and 188 saves.

Wilmer "Vinegar Bend" Mizell was the final piece to the Pirates championship run in 1960. Traded from the Cardinals for Ed Bauta and Julian Javier, Mizell went 13-5 down the stretch for the team, stabilizing the rotation. Mizell pitched another year and a half, ending his major-league career in 1962 with the Mets. He eventually was elected as a congressman from North Carolina.

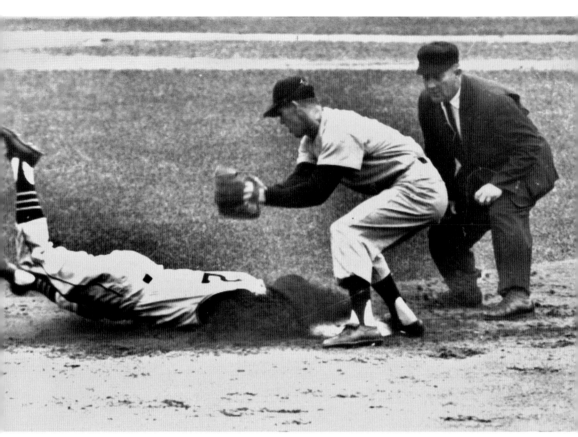

After his phenomenal 1960 campaign for the Pittsburgh Pirates, when he finished runner-up to teammate Dick Groat in the NL MVP vote, third baseman Don Hoak (pictured here sliding into second base), 33, had one more good season in his arsenal: 1961. The Roullette, Pennsylvania, native hit a career-high .298 with 12 homers and 61 RBIs. But it was the beginning of the end for Hoak, as he had a subpar 1962 campaign before being traded by general manager Joe L. Brown in the off-season to the Phillies for Pancho Herrera and Ted Savage. Hoak was released by Philadelphia two years later, ending his major-league career. The third baseman became part of the Pirates broadcasting crew for two seasons before accepting a job as a manager in the Phillies system. Unfortunately, after the 1969 season, Hoak died while behind the wheel. He was chasing the person who stole his brother-in-law's car, and died of a heart attack.

Slugger Dick Stuart had a wonderful 1960 campaign for the world champions. The third-year veteran hit a team-high 23 homers and had a .479 slugging percentage. Despite the fact that the team suffered a disappointing defense of their title in 1961, Stuart had his best season in a Pirates uniform: 35 home runs, 117 RBIs, and a career-high .301 average. Even though the future looked bright for the Bucs first baseman, he had a poor 1962 and was sent to the Boston Red Sox a year later. Stuart hit 75 homers over two seasons in Boston, including 41 in 1963, while leading the league in RBIs (118). After two years in Japan, his 10-year major league career ended in 1969 after a poor season with the Angels.

While he was never the focal point of the Pittsburgh Pirates offense during his 11-year career in the Steel City, the team nonetheless depended on Bill Virdon's consistent bat and phenomenal fielding to help them drive to the NL pennant and world championship in 1960. The 29-year-old center fielder hit eight home runs and drove in 40 runs while hitting .264. Virdon was consistent during his time in Pittsburgh after his first season, never hitting below .243 nor above .279 as a starting center fielder after his initial season in 1956. Virdon had an interesting season in 1962. He had a league-leading 10 triples, but also led the circuit in times caught stealing (13). It was a memorable campaign, though, as he captured his lone Gold Glove. Following the 1965 season, Virdon retired. He came back in 1968 as a coach, and had three at bats as a player, hitting his final homer on July 23.

As impressive as Bill Virdon's playing career was, he may have been even more impressive as a manager. Bucs skipper Danny Murtaugh retired once again after the team won the world championship in 1971, and his former center fielder became his successor. Virdon took this talent-laden squad to its third consecutive Eastern Division crown in his first season on the bench, with an impressive 96-59 mark. In the off season, he lost former teammate Roberto Clemente in a tragic plane accident, and the team never rebounded, struggling in 1973. He was replaced by Murtaugh in the second half. Virdon went on to manage 13 more seasons with the Yankees, Astros, and Expos, winning two division crowns and compiling a lifetime 995-921 record.

Bill Mazeroski had a subpar 1959 campaign, hitting .243. But the Wheeling, West Virginia, native rebounded nicely in the highly successful 1960 season. Maz homered in the double digits for the second time in his career (11) and knocked in 64 RBIs. The slick-fielding second baseman hit .273 and won his second Gold Glove while being selected to play in his third consecutive all-star game. Mazeroski ended the 1960 campaign, of course, with arguably the most memorable home run in the history of the game. He went on to have consistent offensive seasons between 1961 and 1968, becoming an all-star four more times and winning six Gold Gloves. Probably his best campaign during this time was 1966. That year, he had career highs in homers (16) and RBIs (82) and finished 23rd in the vote for National League MVP.

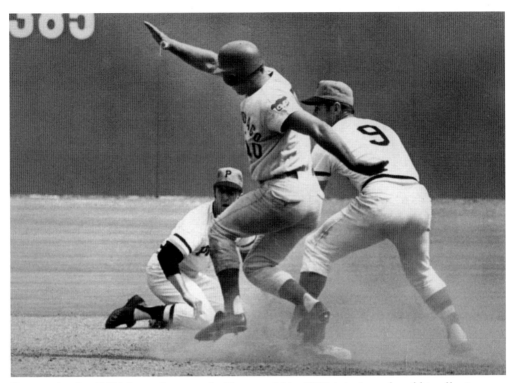

Despite the fact Bill Mazeroski was only 32 years old in 1969, injuries reduced his effectiveness, and he played in only 65 games. After the 1972 campaign, Maz retired from the game, but his status as arguably the greatest defensive second baseman of all time remains. The statistics support this claim. He led the National League in putouts for a second baseman five times, assists nine times, double plays eight times, and fielding percentage three times. For his career, he was seventh all-time in putouts for a second baseman. No one at his position was involved in more defensive double plays than Maz, 1,706. These impressive defensive numbers are the reason Mazeroski was selected by the veterans committee for the National Baseball Hall of Fame in 2001.

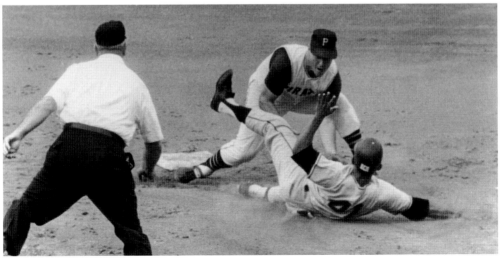

After successful seasons in 1959 and 1960 for the Pittsburgh Pirates, Smoky Burgess enjoyed three more fine campaigns in the Steel City. Burgess exceeded the .300 mark both seasons, hitting .303 and .328, respectively. He spent another season and a half with the Pirates before being put on waivers. He was picked up by the White Sox, with whom he ended his major-league career after 1966.

As good as 1959 was for Rocky Nelson, 1960 was even better for the 35-year old veteran. He hit .300 for the only time in his career and tied his career high in home runs (seven). It was the beginning of the end for Nelson, however. He would spend one more season in the majors, in 1961 with the Pirates, when his batting average slipped to .197.

THE SERIES

GAME 1: OCTOBER 5, 1960, FORBES FIELD
Pittsburgh 6, New York 4
WP: Law (1-0), LP: Ditmar (0-1), S: Face (1)
HR: NY Howard (1), Maris (1), PIT Mazeroski (1)

GAME 2: OCTOBER 6, 1960, FORBES FIELD
New York 16, Pittsburgh 3
WP: Turley (1-0), LP: Friend (0-1), S: Shantz (1)
HR: NY Mantle (2), PIT None

GAME 3: OCTOBER 8, 1960, YANKEE STADIUM
New York 10, Pittsburgh 0
WP: Ford (1-0), LP: Mizell (0-1)
HR: PIT None, NY Mantle (3), Richardson (1)

GAME 4: OCTOBER 9, 1960, YANKEE STADIUM
Pittsburgh 3, New York 2
WP: Law (2-0), LP: Terry (0-1), S: Face (2)
HR: PIT None, NY Skowron (1)

GAME 5: OCTOBER 10, 1960, YANKEE STADIUM
Pittsburgh 5, New York 2
WP: Haddix (1-0), LP: Ditmar (0-2), S: Face (3)
HR: PIT None, NY Maris (2)

GAME 6: OCTOBER 12, 1960, FORBES FIELD
New York 12, Pittsburgh 0
WP: Ford (2-0), LP: Friend (0-2)
HR: NY None, PIT None

GAME 7: OCTOBER 13, 1960, FORBES FIELD
Pittsburgh 10, New York 9
WP: Haddix (2-0), LP: Terry (0-2)
HR: NY Berra (1), Skowon (2), PIT Mazeroski (2), Nelson (1), Smith (1)

Series MVP, Bobby Richardson, New York

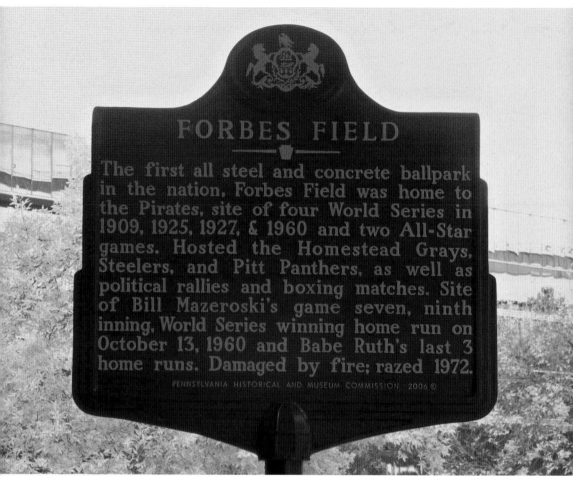

FORBES FIELD

The first all steel and concrete ballpark in the nation, Forbes Field was home to the Pirates, site of four World Series in 1909, 1925, 1927, & 1960 and two All-Star games. Hosted the Homestead Grays, Steelers, and Pitt Panthers, as well as political rallies and boxing matches. Site of Bill Mazeroski's game seven, ninth inning, World Series winning home run on October 13, 1960 and Babe Ruth's last 3 home runs. Damaged by fire; razed 1972.

PENNSYLVANIA HISTORICAL AND MUSEUM COMMISSION 2006 ©

When Forbes Field opened its doors in 1909, Pirates fans were treated to the team winning its fourth National League pennant and earning its second appearance in the World Series. The Bucs defeated Detroit that season for the championship and, 16 years later, won their second fall classic. Pittsburgh beat the Senators, capturing the title in an exciting, come-from-behind 9-7 victory in game seven at Forbes Field. In 1927, the park hosted its third series, when the Pirates lost to the powerful New York Yankees in four straight. The final contest at Forbes Field during that fall classic was a 6-2 defeat in front of 41,634 fans. After three World Series in 18 seasons, it would be almost 33 years to the day until Pirates fans would have a chance to see another, and the Yankees once again would be the opponent. Shown here is the historical marker that stands in Oakland at the former site of Forbes Field. (Courtesy of David Finoli.)

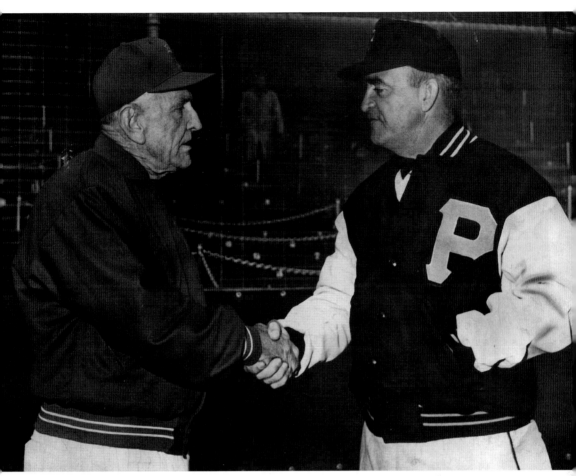

Meeting at Forbes Field before the beginning of the first game of the 1960 World Series are the two opposing managers, the legendary Casey Stengel (left) of New York and the Bucs' 43-year-old skipper, in his fourth season, Danny Murtaugh. Stengel, of course, had a much more celebrated career at this point. The 70-year-old, nicknamed "The Old Perfessor," was at the helm of the Yanks for seven world championships and 10 AL pennants. Murtaugh was one of the main reasons for the Pirates' success. The franchise, which had been among the worst for almost 10 years, turned things around beginning on the day he took over in 1957. While heavily favored, the Yankees could not overcome the Pirates, losing the series in seven games. So disappointed was the New York front office that they relieved Stengel of his job, prompting the veteran manager to say, "I'll never make the mistake of being 70 again."

After Roger Maris opened the scoring of the 1960 World Series with a home run, the Bucs struck for three in the bottom half of the frame. In the fifth, Bill Mazeroski (crossing home plate) hit the team's first home run of the series, a two-run shot to left to give them a 5-2 lead. It would be the last homer the team would hit until the seventh game.

Ahead 5-2 against the favored New York Yankees in the sixth inning of the first game, Bill Virdon, who played in front of the center field wall (pictured), increased the team's lead to four, doubling in Bill Mazeroski in the sixth. Trying to close out the game, Roy Face gave up a two-run homer to Elston Howard, but Pittsburgh held on for the 6-4 victory. (Courtesy of David Finoli.)

THE SERIES

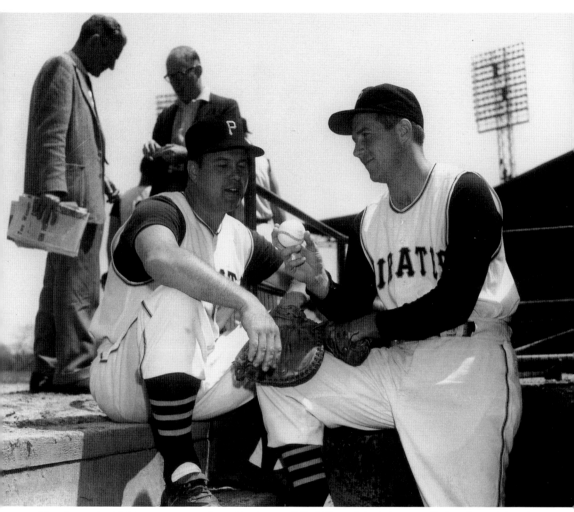

Finishing the 1960 campaign with an 18-12 record, Bob Friend (right) was called on by Pittsburgh to start the second game of the World Series in an attempt to send the Bucs to New York with a dominant two-game advantage. Through two innings, it looked like Friend was up to the challenge, but things started to unravel in the third. Friend, pictured with former Pirate Hank Foiles, allowed two runs on a single by Tony Kubek and a double by Gil McDougald. An RBI single by Bob Turley in the fourth ended the day for Friend, who allowed three runs, two earned, in four innings of work. While not impressive, Friend's performance was better than relievers Fred Green and Clem Labine, who allowed nine more runs. Joe Gibbon surrendered three more in the seventh, and New York tacked on one in the ninth for a 16-3 victory.

The Bucs lost in a 16-3 shellacking at the hands of the New York Yankees in game two at Forbes Field in front of 37,308 disappointed fans. Catcher Smoky Burgess led a 13-hit attack for the Bucs that, unfortunately, yielded only three runs. Burgess had singles in the fourth and ninth, and a walk in the eighth in five plate appearances.

The Yankees were greeted by 70,001 rabid fans for game three of the series, with the teams tied at a game apiece. "Vinegar Bend" Mizell, an important midseason pickup by Joe L. Brown, got the start and did not make it out of the first inning, surrendering four runs (on a Bobby Richardson grand slam) in one third of an inning. The Bucs lost the contest 10-0.

THE SERIES

Things looked dire for the Pirates as they prepared for the fourth game of the 1960 World Series. They were down two games to one and had just been pummeled the previous two games by a combined 26-3 margin. Cy Young Award winner Vern Law, the game one winner, was about to take the mound against Ralph Terry. It was a pivotal matchup. If the Pirates could not find a way to win, it could mean a disappointing end to their season. It would be extremely difficult for them to come back against a team as good as the Yankees. Law was certainly up to the challenge, as he had been all year. After surrendering a Bill Skowron home run in the fourth, Law contributed offensively, tying the game at one with a double to left field that scored Gino Cimoli, who had led off the top of the fifth with a single to right.

With the score tied at one in the top of the fifth inning of the fourth game of the World Series, centerfielder Bill Virdon came to the plate with Smoky Burgess on third and Vern Law on second. With two out, Virdon gave Pittsburgh the lead when he stroked a single to center, scoring both runners. The Pirates had a 3-1 lead.

In the bottom of the seventh inning, Danny Murtaugh turned over the game to ace reliever Roy Face. The Yankees had knocked out starter Vern Law when Bobby Richardson cut the lead to one with a groundout to second that scored Gil McDougald. Face was dominant, retiring New York in order over the last two and two-thirds innings for his second save of the series.

"The Kitten," as 35-year-old southpaw Harvey Haddix was called, got the nod in game five of the 1960 World Series. He hoped to give the Pirates an advantage in the fall classic before they returned to Forbes Field. Haddix was as dominant as Vern Law had been the day before, allowing only five hits, two walks, and two runs in six and one-third innings.

Yankees manager Casey Stengel pulled starter Art Ditmar in the second inning, after Ditmar surrendered three runs to the Bucs. "The Old Perfessor" called on former Pirate Luis Arroyo to stop the momentum. The Puerto Rico native had found his niche with the Yanks, following his less-than-stellar two-year career with Pittsburgh, where he had finished 6-14. Arroyo was not at his best, giving up two hits and a run in the contest.

Don Hoak, the hard-nosed third baseman for the Pirates, came up in the second inning of game five of the 1960 fall classic with men on second and third and one out. He smashed a ball to Tony Kubek at short, and Kubek went to third to try and retire Smoky Burgess. Gil McDougald missed the ball, and Gino Cimoli scored, giving the Bucs a 1-0 lead.

While he would play a more important role for the Pirates in game seven, second baseman Bill Mazeroski would be pivotal in bringing the Bucs to within one game of a world championship. Maz doubled to left field in the top of the second, scoring two runs. Pittsburgh took a 3-0 lead. The Pirates added two more and won the fifth game 5-2.

THE SERIES

The series returned to Forbes Field for game six. Murtaugh once again called on hurler Bob Friend in hopes that he would be more effective than he had been in the second game. Unfortunately, he was not. After setting the Yankees down in order in the first, he gave up two runs in the second on a Whitey Ford single, and two more in the third before being replaced by Tom Cheney.

Mickey Mantle (7) looks on as Pirates catcher Smoky Burgess tries to make a spectacular catch in game six. Mantle went on to knock in two runs on a third-inning single in the Yankees' dominant 12-0 victory. Mantle had a tremendous series, hitting .400 with three home runs and 11 RBIs.

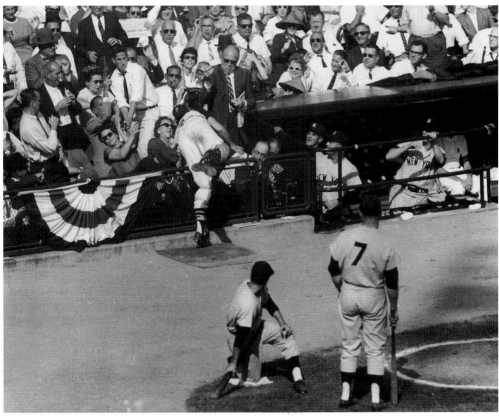

THE PITTSBURGH PIRATES' 1960 SEASON

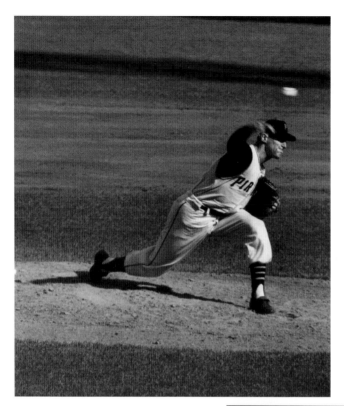

Cy Young Award winner Vern Law continued his phenomenal season in the 1960 World Series, winning both his starts for the Pirates. Manager Danny Murtaugh confidently gave him the ball for the seventh game. The Bucs gave him an early 4-0 lead, but the Yankees chipped away, making it 4-3 in the sixth. Law was lifted in favor of Roy Face.

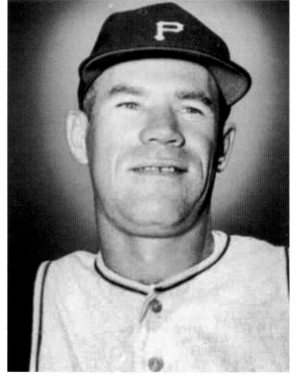

After Bill Mazeroski's home run early in the first game of the 1960 fall classic, no Pirate repeated the feat in the next five games. But, in the bottom of the first of the seventh game, that changed. After Bob Skinner got aboard with a two-out walk, Rocky Nelson (pictured) made it 2-0 with the Bucs' second home run of the series.

THE SERIES

Shown here as Pirates teammates in 1961 are pitchers Bobby Shantz (left) and Roy Face (right). In game seven of the 1960 World Series, however, they faced each other in relief. Shantz went five innings for New York, giving up three runs. Face, who had saved each of the Pirates' three wins in the series, replaced Vern Law in the sixth inning and surrendered four, giving the Yanks a 7-4 lead.

With the Pirates' championship hopes now fading, down 7-4 in the bottom of the eighth inning, Pittsburgh began to rally. Scoring a run on a Dick Groat single, the Bucs had two out when Roberto Clemente, shown here congratulating Nelson after his homer, hit a grounder to first in what looked to be the third out. Hustling down the line, he made it to the bag safely, keeping the inning alive.

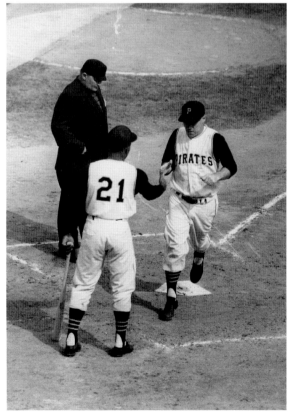

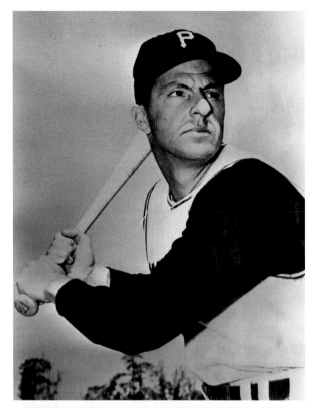

Game seven of any sport gives an opportunity for average players to become legends in a single moment. In the bottom of the eighth inning of the 1960 World Series, Hal Smith got such an opportunity: the chance to rise from little-known player to a hero in Pittsburgh sports lore. The scene was as follows: the Pirates were down 7-6 with two out in the bottom of the eighth. Dick Groat was on third and Roberto Clemente was on first. Smith, who had replaced Smoky Burgess in the top of the inning, came to the plate. He ripped a Jim Coates pitch over the left field wall to give the Pirates a 9-7 lead.

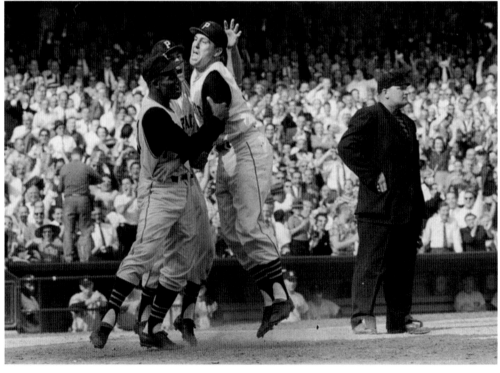

THE SERIES

If Hal Smith became a Pittsburgh sports hero in the bottom of the eighth, then what Bill Mazeroski did an inning later certainly made the Wheeling, West Virginia, native an outright icon. The Yankees had tied the score in the top half of the ninth, quieting what had been a raucous Forbes Field crowd following Smith's long ball in the bottom of the eighth. Mazeroski strolled to the plate to lead off the bottom of the ninth. Ralph Terry was on the mound. At 3:36 p.m., Terry let go of a one-ball, no-strike pitch. Mazeroski launched it deep over the left field wall, setting off one of the wildest celebrations the city has ever seen.

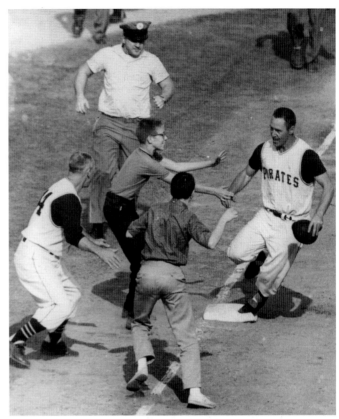

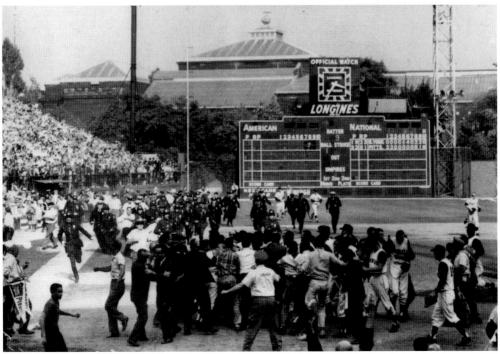

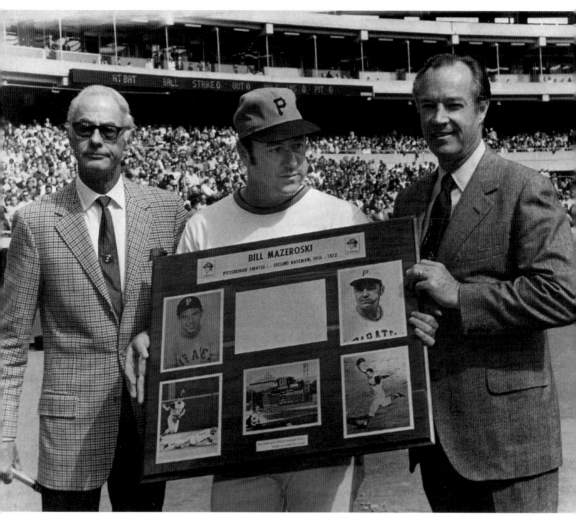

Legendary Pirates announcer Bob Prince (left) and general manager Joe L. Brown (right) present Bill Mazeroski with a plaque late in the 1972 campaign, commemorating the retiring second baseman's career. Prince and Maz met 12 years earlier, in a much more joyous setting, in the Pirates locker room after Mazeroski ended the World Series with a home run. Prince had been shuttled back and forth from the booth to the locker room in the ninth inning as the fortunes of the game alternated. When he interviewed Mazeroski after the game, he did not actually know that the Wheeling native had hit the memorable homer. Given to him by his producer to interview first, Prince asked Maz a few generic questions, then pushed him aside to interview more players. Prince said later on that his wife was the one who informed him, after he left the locker room, of Mazeroski's feat.

While the celebration in the streets of Pittsburgh was a sight to behold after the exciting 10-9 series-clinching victory, the one in the locker room was no less memorable. Pictured at right are manager Danny Murtaugh (left) and Hal Smith. Below, third baseman Don Hoak pops open a celebratory bottle of champagne. Along with his memorable eighth-inning homer in game seven, Smith hit .375 in eight World Series at bats. Hoak was not as successful, hitting only .217 for the series, but his contributions during the season were a major factor in the team winning the pennant and playing in the fall classic.

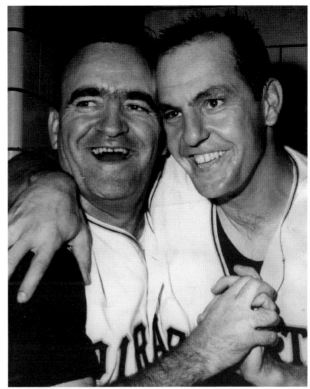

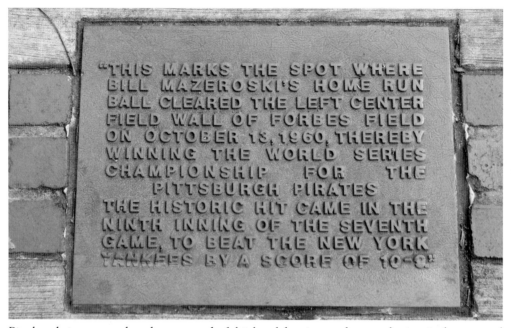

"THIS MARKS THE SPOT WHERE BILL MAZEROSKI'S HOME RUN BALL CLEARED THE LEFT CENTER FIELD WALL OF FORBES FIELD ON OCTOBER 13, 1960, THEREBY WINNING THE WORLD SERIES CHAMPIONSHIP FOR THE PITTSBURGH PIRATES THE HISTORIC HIT CAME IN THE NINTH INNING OF THE SEVENTH GAME, TO BEAT THE NEW YORK YANKEES BY A SCORE OF 10-9"

Pittsburgh is a town that does a wonderful job celebrating and remembering its heroes and special places. The markers installed in the Oakland section of the city at the University of Pittsburgh, where Forbes Field stood, commemorate the 1960 World Series, and they are a must for any baseball fan to see. Pictured above is a plaque on the sidewalk that marks the exact spot where the ball that Bill Mazeroski hit to win the championship flew over the left field wall. The below photograph shows the exact location of the ivy-covered brick wall of Forbes Field. (Both, courtesy of David Finoli.)

THE SERIES

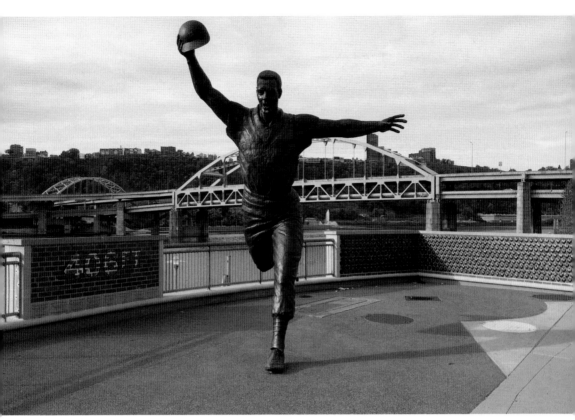

The year 2010 marked the 50th anniversary of the only home run in World Series history to end a seventh and deciding game. There were several celebrations and honors for Bill Mazeroski and his teammates, including a huge throng at the Forbes Field wall in Oakland. The crowd listened to a rebroadcast of the memorable contest. In addition, an etching was placed in the sidewalk, commemorating the hall of fame second baseman, right beside where his home run took place. Probably the biggest monument of the year was a bronze statue that was unveiled outside the right field gate at PNC Park. The statue of Mazeroski pumping his cap as he rounded the bases is accompanied by the actual "406" sign that was on the wall over which the home run sailed. Standing 14 feet and weighing 2,000 pounds, the statue will remind generations of Pirates fans of the most special moment in the franchise's long history. (Courtesy of David Finoli.)

DISCOVER THOUSANDS OF LOCAL HISTORY BOOKS FEATURING MILLIONS OF VINTAGE IMAGES

Arcadia Publishing, the leading local history publisher in the United States, is committed to making history accessible and meaningful through publishing books that celebrate and preserve the heritage of America's people and places.

Find more books like this at
www.arcadiapublishing.com

Search for your hometown history, your old stomping grounds, and even your favorite sports team.